IMAGES
of America

FILIPINOS IN
PUGET SOUND

IMAGES
of America

FILIPINOS IN
PUGET SOUND

Dorothy Laigo Cordova and the
Filipino American National Historical Society

ARCADIA
PUBLISHING

Published by Arcadia Publishing
Charleston SC, Chicago IL, Portsmouth NH, San Francisco CA

Printed in the United States of America

Library of Congress Control Number: 2008941565

For all general information contact Arcadia Publishing at:
Telephone 843-853-2070
Fax 843-853-0044
E-mail sales@arcadiapublishing.com
For customer service and orders:
Toll-Free 1-888-313-2665

Visit us on the Internet at www.arcadiapublishing.com

*To my parents and their peers who laid the foundation
for our Filipino communities and to my husband, who
encouraged me to finally write their history.*

CONTENTS

FOREWORD

Dorothy Laigo Cordova is a book author in her own right. It's about time!

It's taken some decades in her daily non-salaried administration of the Filipino American National Historical Society—more than 25 years to be exact, not counting the other 40 years of volunteerism, youth work, community activism, researches, oral history projects, photograph exhibits, conferences, and ecclesial contributions in between teaching, consulting, tutoring, mentoring, and being wife and a mother of 8, grandmother of 16, and great-grandmother of 4.

This book is her very own, from its inception, photograph choices, writing, layout, and many sleepless off-hours.

It is her work of love for people, especially her own Filipino Americans right in her very native city, Seattle, with its Pinoy community, which nurtured her to do what not too many can do.

Of the most well-liked with the surname Cordova, it has to be Dorothy Montante Laigo Cordova, she with an honorary doctorate in humanities from Seattle University and having held a professorship at the University of Washington. She is one of the rarest who instills in her immediate family in outreaching to all others kindness, patience, compassion, respect, tolerance, strength, fortitude, service, and all the other Catholic virtues and Philippine values because she is a Laigo with Castillano paternalism, thanks to her parents.

Yes, thanks to Bibiana, Valeriano, and Mike with the grace of God. However, whenever anyone asks about me, I simply say, "Thanks to God and to Dorothy!"

—Frederic A. Pilar Cordova, LHD

ACKNOWLEDGMENTS

When I decided to write *Filipinos in Puget Sound*, I was lucky to have access to thousands of photographs collected through various project of my former organization, Demonstration Project for Asian Americans, and my present love—the Filipino American National Historical Society (FANHS). What began as a simple way to tell the history of Filipinos in Puget Sound ended up a trip down memory lane. Dear relatives and friends—most now gone—came back to life as young people looking for a new beginning in America.

Since 2009 is significant for three groups, I focused a bit on Bontocs at the 1909 Alaska-Yukon-Pacific Exposition, Jenkins family (100 years), and the Filipino Youth Activities Drill Team (50 years). As photographs were grouped into a cohesive historic montage, I realized the 240 photographs the publisher allotted this project could not fully tell the story of Filipino Americans in the region of the past 100 years. What to cut and what additional photographs to seek became an urgent task during the past few weeks of this project. If readers fail to see their families, I apologize. If captions are askew, *mea culpa*. If there is too much of Seattle, it is because Seattle drew people for many social and cultural events.

Special thanks go to my husband, Fred, who encouraged me and helped write captions and the first chapter introduction as the project deadline was approaching. I am indebted to Nancy Ordona Koslosky, who gathered many photographs during earlier oral history projects; to Bob Flor, Mia Mendoza, Joann Oligario, and Filipino Youth Activities (FYA) for giving FANHS valuable albums and photographs; to the Beltran, Laigo-Castillano, and Sumaoang families and Diana Floresca Kelting, Doug Luna, and Pio DeCano, who shared family treasures; and to Jeannette Castillano Tiffany, who taught the importance of good photographs. I am grateful to Marya Castillano-Bergstrom, Alma Kern, Bert Caoili, Sluggo Rigor, and Bobby Fletcher for gathering specific photographs; also Marcial Cordova-Sanchez, T. J. Sanchez, Cecilia Cordova, and Jay O'Connell, who scanned and downloaded photographs; and Timoteo Cordova for the poster page.

For others who lent photographs—thank you, *Dios ti agnina, Salmat po*.

The sources for some images in this book are noted as follows: Filipino American National Historical Society (FANHS) are Filipino Youth Activities (FYA).

INTRODUCTION

This book will give readers a glimpse of the long and varied history of Filipinos who immigrated and settled in Washington state's Puget Sound region since the early 19th century. This area, bound on the north by Canada and the capital city of Olympia to the south, contains a deep, inland sea surrounded by rich and verdant land, which once was covered by forests and contained rivers and other waters teeming with salmon. There are islands nestled in the sound, and within sight on either side are two beautiful mountain ranges—the Olympics and the Cascades. The beauty must have enchanted new arrivals.

In 1788, the *Iphigenia Nubiana*, a British trading and exploring ship anchored off Vancouver Island, listed a "Manilla man"—the captain's servant. Other early Filipino seamen on British and German ships remained and intermarried with local native women. The 1888 documents of Port Blakely (on Bainbridge Island)—at the time the largest lumber mill in the world—listed a "Manilla," first known employee from the Philippines in the region. At the conclusion of the Spanish-American War, the Philippine Islands were sold by Spain to the United States for $20 million, making it America's first overseas colony. Filipinos—now American "nationals"—could come to America without passports.

By 1906, early Filipinos were laying telephone and telegraph cables from Seattle to the territory of Alaska. After completing their contracts, some remained here. The 1909 Alaska-Yukon-Pacific Exposition proclaimed Seattle the gateway to the gold riches of Alaska and the closest U.S. port to the Far East. That same year notes the arrival of the first known Filipino family—the Jenkins family.

For the next three decades, Filipinos immigrated to Puget Sound to continue their education or seek jobs in salmon canneries, small truck farms, lumber mills, restaurants, or as houseboys. The ratio was one Filipino woman to 30 Filipino men. This disparity caused many men to marry women of other races—Caucasian, Native American/Alaska native, African American, Hispanic, and Japanese. Washington state had no anti-miscegenation laws. Consequently, most early Filipino families in Puget Sound were interracial.

Through the pages and photographs in the book, readers will see how historic events in American life—such as the Great Depression, World War II, civil rights, and changes in immigration—affected Filipino immigrants, their children, and their children's children.

As the chapters progress, the Filipino communities will change, but so has this great Puget Sound region. Once covered by forests, teeming with fish, with many small and productive farms, some forested areas and farmlands have been replaced with malls, new suburbs, and towns, and some small towns have become cities. And our wonderful Puget Sound waters are now endangered.

Today Puget Sound continues to draw Filipinos here to set down roots. And this is still "God's country."

One

COMING TO AMERICA

The year 1909 ushered into the Puget Sound country a group of different peoples from the Philippines—Bontoc and Jenkinses. The common ground was in Seattle.

The Bontoc were Igorot; 50 came from the Cordillera mountain provinces in Northern Luzon. These Filipinos comprised an ethnic cultural minority.

To Americans, they had been depicted as "savages" and "aborigines" because these loin-clothed Igorot were dubbed "wild peoples, headhunters from the Philippines." Such headlines drew thousands to the Alaska-Yukon-Pacific Exposition (AYPE) from June to October 1909 on the University of Washington campus. The Bontoc constructed their Igorrote Village, where they danced to exotic sounds of gongs echoing over Lake Washington and forested residential hills.

Despite the Bontoc "cultural zoo" being the hit of AYPE, many Seattleites held for decades negative attitudes toward all persons of Filipino descent. All Igorot culture was vilified.

As for the Jenkinses, they, too, became historic personalities in Filipino American history. Rufina Clemente Jenkins, a Filipina war bride of the Spanish-American War, was the wife of army sergeant Frank Jenkins, an African American whose mother was Mexican. That is a story in itself. Husband and wife with their four children came to homestead permanently in Seattle. Thus, in 1909, Seattle had its very first Filipino family. Actually, the family was not only the first Filipino but also Seattle's first Asian-African-Latino American family.

The eldest of the Jenkins children was Francisca, Philippine-born and Tagalog-speaking. Three brothers followed, all second-generation Filipino Americans: Frank Jr., Ed, and Andrew. Within 100 years, the Jenkins descendants would include 6 grandchildren, 12 great-grandchildren, 14 great-great-grandchildren, and 16 great-great-great-grandchildren (now sixth-generation Filipino Americans).

On behalf of all the Jenkinses, Frank and Rufina's granddaughter Dolores Bradley would always proclaim, "We are proud of our Filipino heritage."

Eventually more Filipinos would come to Seattle in three immigration waves, the last in 1965 to start a Pinoy population explosion. Complementing the Filipino American experience are the descendants of all those Philippine-born who came to Puget Sound since 1883, many of them the multiracial American-born Filipinos,

Welcome to Filipino America on the shores of the Puget Sound.

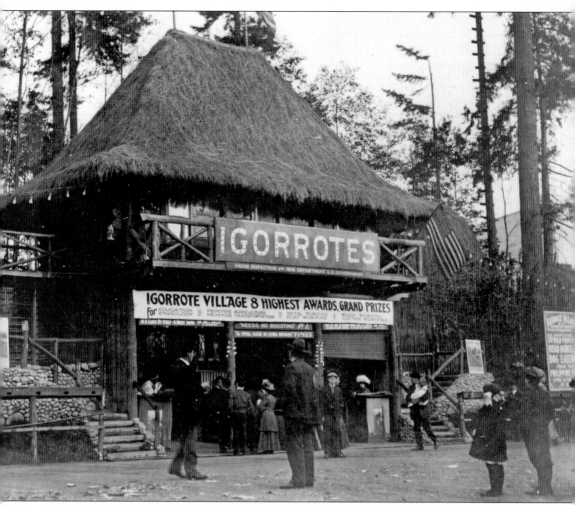

Despite negative attitudes harbored toward the Bontoc in the Alaska-Yukon-Pacific Exposition in 1909 at the University of Washington, the Igorot won eight highest awards, grand prizes for education and ethnology in primitive agriculture and transportation and, respectively, in metal, clay, wood, and cotton workings. Bontoc, named Igorrotes, were being exhibited under the inspection of the U.S. War Department, now the Department of Defense. (Photograph from Special Collection Division, University of Washington Libraries.)

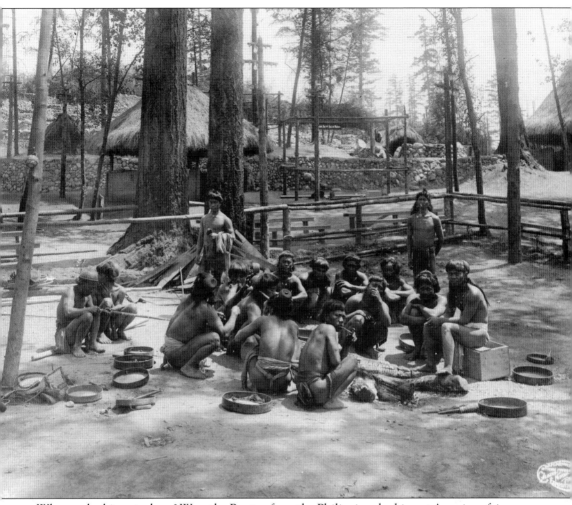

Who was looking at whom? Were the Bontoc from the Philippines looking at American fairgoers at the 1909 Alaska-Yukon-Pacific Exposition on the University of Washington campus, or vice versa? The Igorot from a Philippine mountain province became the AYPE's heralded venue from June to October. Bontoc were expected to do their dances with gongs and maintain their Igorrote Village, whose enclosures and huts are shown. (Photograph from Special Collection Division, University of Washington Libraries.)

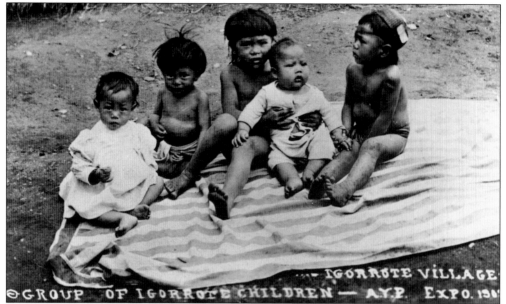

Small urchins they are not but the youngest citizens of the Bontoc from the Philippines in the Alaska-Yukon-Pacific Exposition's Igorrote Village in 1909 at the University of Washington. Typical Filipino children, they wait patiently for their respective parents by remaining where they had been told to stay. The oldest of the five already shows responsibility by caring for the youngest. (Photograph from Special Collection Division, University of Washington Libraries.)

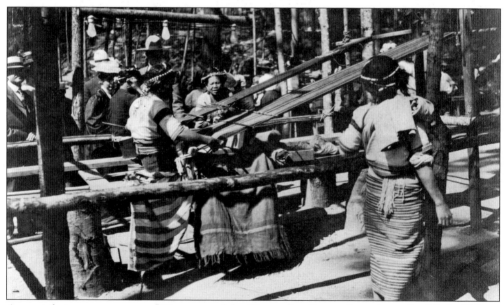

Agonai, facing out, was one of 10 women of the 50-member Bontoc brought to the Alaska-Yukon-Pacific Exposition in 1909 at the University of Washington campus. She is weaving colorful clothing and tapestries with other Bontoc women while fairgoers watch. Agonai is also one of two women who gave birth in Igorrote Village, to give Seattle one of the first two Filipino Americans of the second generation. (Photograph from Special Collection Division, University of Washington Libraries.)

This is the wedding certificate of Capt. Frank Jenkins, a Buffalo soldier stationed in the Philippines after the Spanish-American War, and Rufina Clemente of Nueva Caceres, who were married May 3, 1901, in the Philippines. Rufina was one of the first "war brides" to come to America. (Courtesy FANHS.)

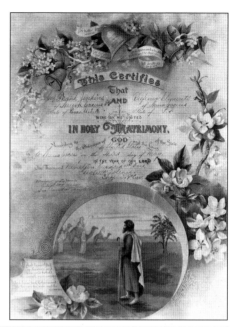

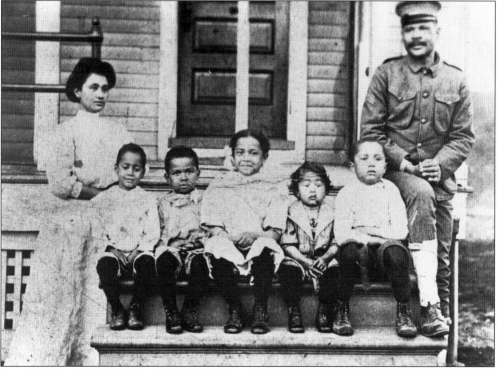

Sgt. Frank Jenkins, his wife, Rufina, and (from left to right) son Ed, neighbor child, daughter Francesca, and sons Andy and Frank Jr. sit in front of their home at Fort Lawton's non-commissioned officers' area at Fort Lawton in Seattle. Sergeant Jenkins's father was a runaway slave, and his mother was a Mexican from Texas. During his service in the Philippines, he served as a Spanish interpreter for the U.S. Army around 1912. The Jenkins family was the first permanent Filipino American family in Seattle. (Courtesy FANHS.)

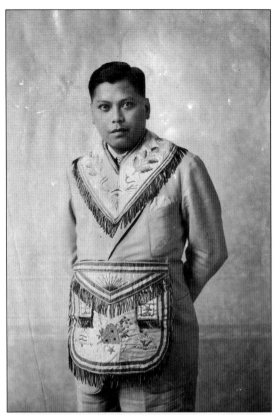

Pio DeCano Sr. proudly poses in the regalia of the Caballeros de Dimas Alang, one of the most influential Filipino lodges in America. He was a labor contractor and community leader who fought for the right of Filipinos to own real estate. DeCano began a three-year court action, first in the King County Superior Court in 1937, which resulted eventually in a landmark decision in 1941 allowing Filipinos to legally own land in Washington state. (Courtesy FANHS.)

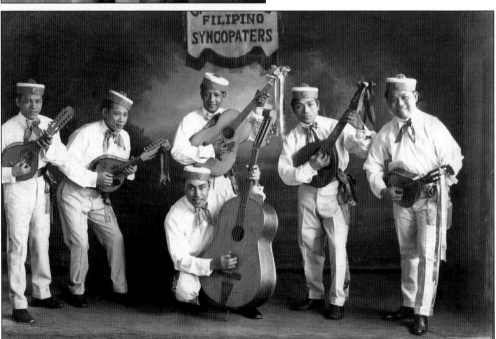

After retiring from the U.S. Navy, Phil Monzon was a member of Captain Cooper's Filipino Syncopaters as the band bass player. This image is from around 1920. (Courtesy Doug Luna.)

Josefa Perez Diaz Barrazona (right), a teacher in the Philippines, came to America in 1921 to study. She poses with her younger sister, Nene Espiritu (left), and another student in Seattle. (Courtesy *Filipinos: Forgotten Asian Americans* by Fred Cordova.)

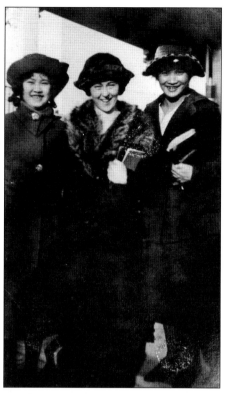

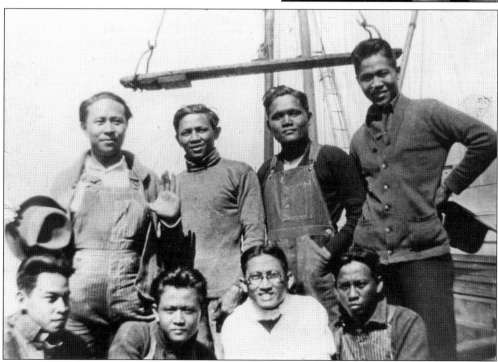

Bob Flor (far left) was one of several Filipino crew members on a National Geodetic Survey ship that traveled through Puget Sound to Alaska around 1927. (Courtesy Robert Flor and FANHS.)

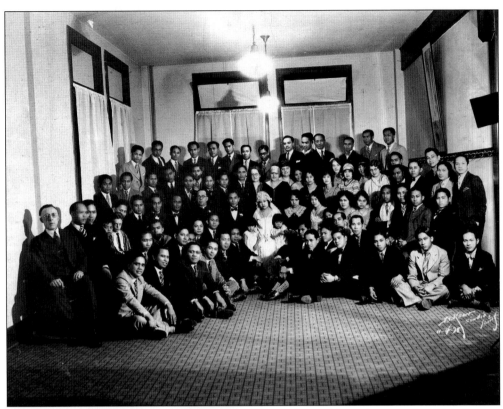

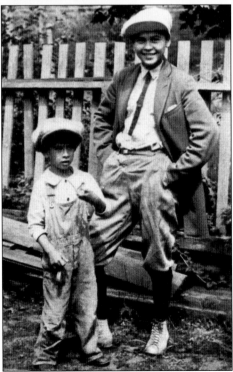

Here is the wedding photograph of Valeriano M. Laigo and Bibiana Montante. Valeriano came to Seattle in 1918 when he was 18 and became a successful businessman. Although Bibiana arrived in 1928 to study, she was courted by Valeriano. They were married November 18, 1928. (Courtesy Dorothy Cordova and FANHS.)

Two unidentified "mestizo" boys pose while playing in their Port Blakely neighborhood around 1928. (Courtesy Bob Santos and FANHS.)

At the beginning of the Great Depression, Francesca Jenkins Robinson was a young widow with two small children, Dolores and Sonny. After her husband Horace's death in a veteran's hospital in the Bay Area, she returned to Seattle. She said the Depression did not bother her because she lived with her mother and father, now retired and with a pension, and she worked for the government. This image is from about 1929. (Courtesy Dolores Bradley.)

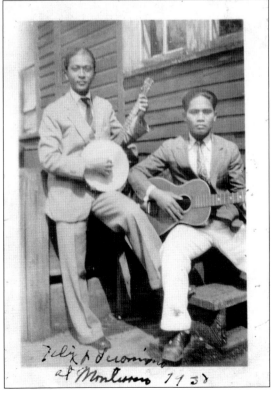

Felix Dilodilo from Bauang, La Union, plays the mandolin while his friend strums the guitar around 1928. Dilodilo came to America with his brother. Although Seattle was his home base, they did seasonal work in lumber mills, in Alaska, and on farms. (Courtesy Susan Dilodilo McIlhenny and FANHS.)

17

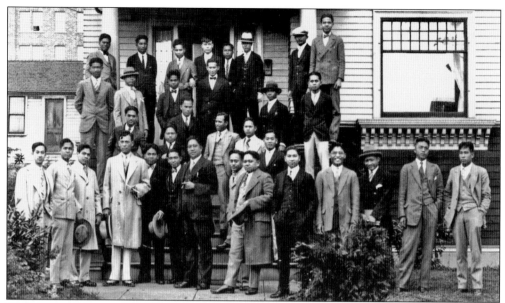

Well-dressed Filipino undergraduate and graduate students at the University of Washington pose by the home where several resided around 1927. This group advocated the need for a community center for young Filipino students and other immigrants. Before the Great Depression, several Filipino businessmen donated funds. Over the years, community queen contests also raised funds. A community center did not materialize until 1965. (Courtesy FANHS.)

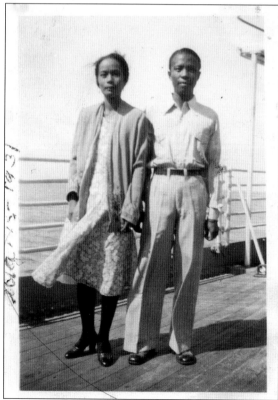

Juliana Mendoza is aboard a ship bringing her to Seattle, where she joins her husband, Saturnino, around 1931. She was one of only 25 or so Filipino immigrant women living in Seattle during the 1930s. She became the matriarch of the Mendoza clan. (Courtesy Mia Mendoza and FANHS.)

Two

CREATING COMMUNITIES

These were difficult years. Filipinos had to endure the Great Depression, growing discrimination, and the changing of their legal status in this country.

During the Depression, laborers on farms earned a mere 10¢ an hour, and work in Alaska canneries and lumber mills was often seasonal. However, Filipinos took care of one another. Employed men shared hotel rooms with unemployed relatives and friends. Families cooked extra food for the "person who might show up for dinner." The Filipino Woman's Club took care of the sick, and Lodges buried their dead. They were also resourceful—digging clams, jiggling for squid, fishing, and going to Frye's Meat Packing House or the Public Market for soon to be discarded pig's feet and tails or salmon bellies and cheeks. They grew familiar vegetables or picked so-called "weeds" to add to *sinigang*—a Philippine soup.

In 1934, the U.S. Congress passed the Tydings-McDuffie Act, by which the Philippines was no longer its colony but a commonwealth that would gain independence in 10 years. Consequently, Filipinos were no longer nationals with the freedom to come to America without passports. They were now "aliens," and the immigration quota of only 50 a year was imposed. Filipino immigrants could neither own property nor vote, but they could pay taxes.

Although discrimination escalated, early Filipino communities flourished because they were connected through kinship, Philippine regional ties, churches, organizations, and lodges. An active social life included people from different cities, towns, and rural areas. Young Filipino men emulated Hollywood actors in the way they dressed, while Filipino women retained traditional Philippine styles for formal social gatherings.

There were families—mostly interracial—and slowly a second generation of Filipino Americans developed. Most did not speak their immigrant parents' dialects—but some understood and responded in English. Along with other people of color, Filipinos were restricted to certain neighborhoods. Thus American-born children attended the same schools and churches and often socialized with one another.

As the country slowly recovered from the economic woes of the Great Depression, the wars in Europe and Japanese encroachments in the Far East made many uneasy.

Phil and Matilda Monzon play with their two children, Corinne and Philip Jr., around 1932. The family lived on the northwest side of Beacon Hill, which youngest daughter Camille Monzon Richards recalls was racially diverse, including Russian families who had fled during the Bolshevik Revolution. (Courtesy Doug Luna.)

On their wedding day, Joe Balagot (top, left) and his bride, Myrtle Hand, pose for a photograph with his brother George (first row, center) and two friends around 1932. Very often, photographs such as these were sent to families in the Philippines. (Courtesy *Filipinos: Forgotten Asian Americans* by Fred Cordova.)

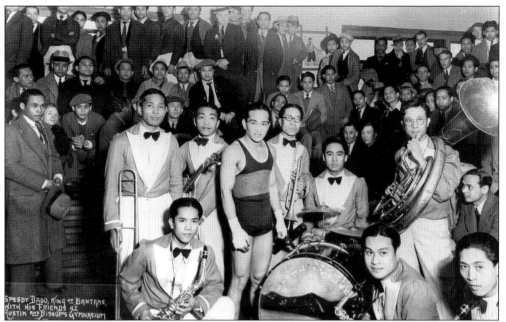

Speedy Dado, King of Bantams, stands among members of a Filipino jazz band that entertained a crowd of men watching the ranked boxer train for a bout in Seattle's Austin and Bishop's Gymnasium around 1933. Boxing was a popular spectator sport for Filipinos along the West Coast. (Courtesy *Filipinos: Forgotten Asian Americans* by Fred Cordova.)

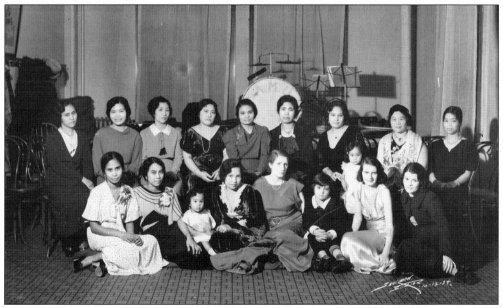

In 1934, the Filipino Women's Club included the Caucasian wives of Filipinos. From left to right are (first row) Genevieve and Ida Ordonia, Dorothy and Bibiana Laigo, Margaret and Dolores Duyungan, and two unidentified; (second row) unidentified, Dolores Gonoong, Felicidad Acena, Paula Nonacido, Pilar DeCano, Maria Beltran, Aurea and Dolores Domingo, unidentified, and Belen Braganza. In an interview, Belen recounted that the club raised funds to help sick and out-of-work Filipino immigrants. (Courtesy FANHS.)

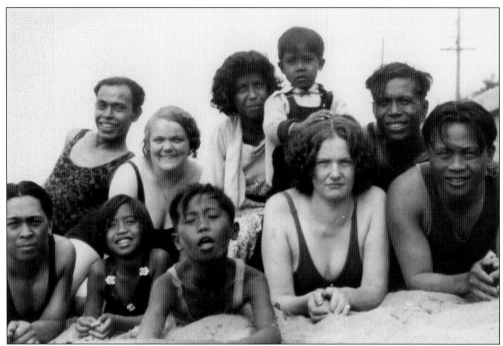

Occasional hot weather in Puget Sound brought people for a day at the beach around 1932. From left to right are (first row) unidentified, Rose and Leo Mamon, and two unidentified; (second row) two unidentified, Phyllis Mamon and her little brother Bill, and Phil Bracero. (Courtesy Ramona Bracero and FANHS.)

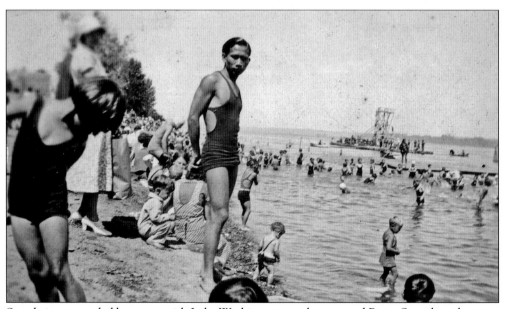

Seattle is surrounded by water, with Lake Washington on the east and Puget Sound on the west, and two other lakes are within the city boundaries. Fred Sumaoang enjoys a c. 1933 summer swim at a local beach. (Courtesy Fanny Sumaoang and FANHS.)

Maria Abastilla Beltran from Baguio (left) was a public health nurse who came to America in 1929 and one of seven or eight Filipina nurses who worked in Seattle hospitals or sanitariums during the 1930s. Aurea Domingo (right) came with her husband, Leo, from Ilocos Sur in 1929. This image is from around 1935. (Courtesy Jim Beltran and FANHS.)

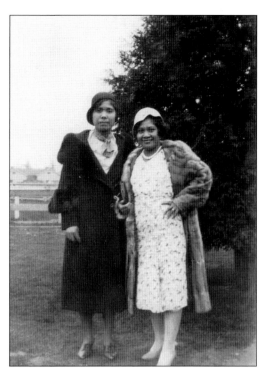

Mrs. Rafaela Camposano Hamoy (right) and her friend pose stylishly with fur stoles and similar berets around 1933. Hamoy went to Hawaii in 1909 and then came to Seattle in 1912, where she raised her four children. At one time, Hamoy had a small combination ice cream parlor and pool hall in Chinatown. (Courtesy FANHS.)

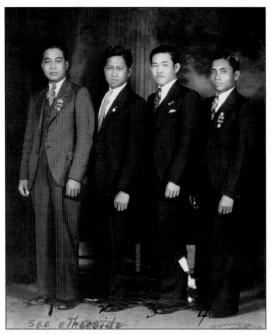

Filipinos worked in Alaska salmon canneries under substandard working and living conditions. After years of grassroots organizing, a union to correct these injustices was formed in 1933. Founders and officers of Cannery Workers and Farm Laborers Union are, from left to right, Virgil Duyungan, Tony Rodrigo, Cornelio Misland, and A. E. Espiritu. (Courtesy FANHS.)

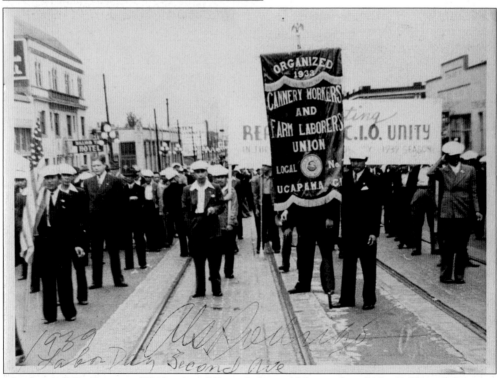

Members of the Cannery Workers' and Farm Laborers' Union, Local No. 7, United Cannery Agricultural Packing and Allied Workers of America (UCAPAWA), prepare to march in a *c.* 1939 Labor Day parade. This Filipino union had members throughout the West Coast. Their float preceding the marching group declared the union's pledge of "Equal Pay for Equal Work." (Courtesy FANHS.)

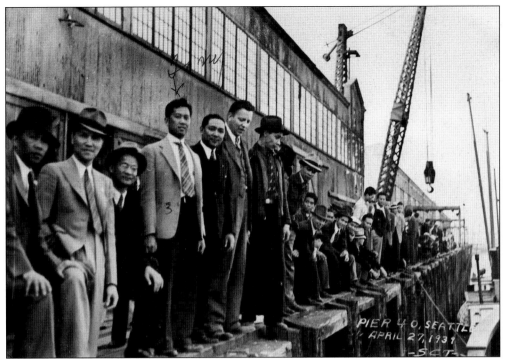

During the early part of the 20th century, Pier 40 in Seattle was the scene of boats bringing thousands of Filipinos to the different canneries throughout Alaska. *Alaskeros*, as they were called from the 1930s–1970s, did not fly to their summer work until the late 1940s. Pictured are union officers including Tony Rodrigo (fourth from left) and Vincent Navea (fifth from left). (Courtesy FANHS.)

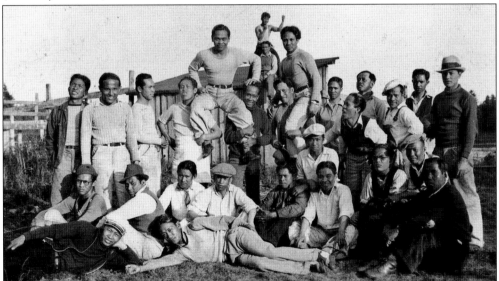

Cannery work was seasonal and contracts were for three months—from May through September, for salmon runs began in the north and ended in south Alaska. Town mates from Bauang, La Union, worked in the Tenakee Cannery. After their summer work in Alaska, some returned to seasonal work on Puget Sound area farms or in Seattle. (Courtesy FANHS.)

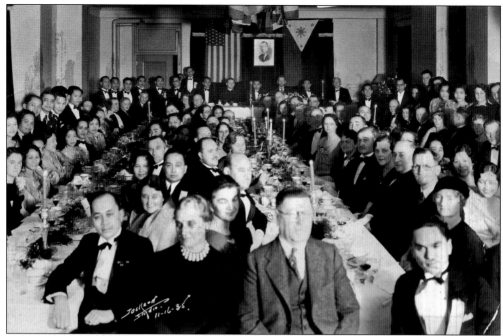

To commemorate the November 15, 1935, inauguration of the Philippine Commonwealth government in Manila, Filipino leaders of the different community organizations celebrated at a formal banquet also attended by local dignitaries. While planning this event, leaders agreed to form a new organization—the Philippine Commonwealth Council of Seattle—which elected Pio DeCano as president and Rudy Santos the vice president. In 1940, this organization was incorporated as the Filipino Community of Seattle and Vicinity. (Courtesy Jim Beltran and FANHS.)

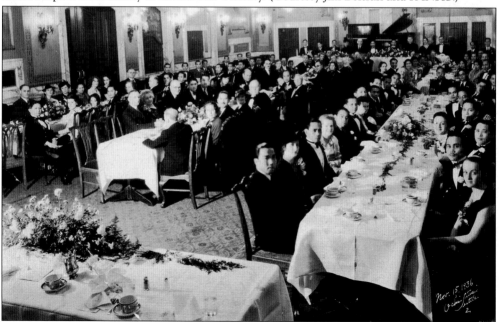

The Philippine Commonwealth government's first anniversary dinner also drew a number of Filipino men with their white wives or dates. (Courtesy FANHS.)

The 1936 funeral of Valeriano M. Laigo, who was killed by a former business associate, was at Our Lady Queen of Martyrs Church. The highly respected community leader left a widow, Bibiana, and their five children, pictured directly behind the casket. Laigo, the patriarch of his large family in Seattle, brought many of them to America. (Courtesy FANHS.)

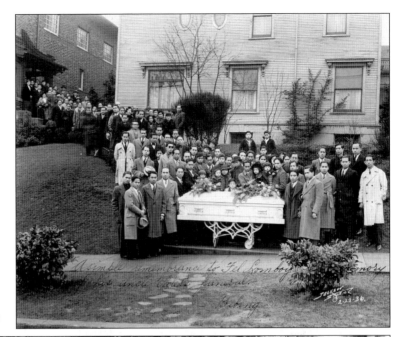

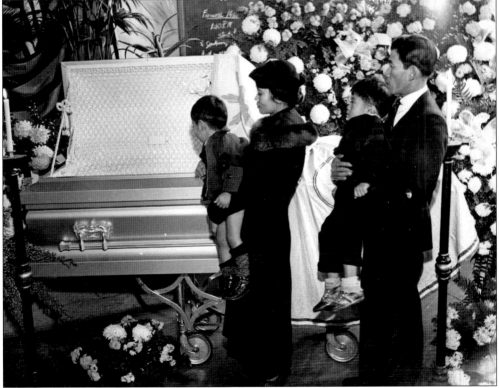

In November 1936, Alaska Cannery Workers Union president Virgil Duyungan and secretary Aurelio Simon Sr. were murdered in a Japan Town restaurant. These killings unified members, who rallied to help the families. Pictured above at a memorial service is Simon's widow, Matilda, holding son Ben while son Aurelio Jr. is held by an unidentified man. (Courtesy FANHS.)

Fred Floresca holds his newborn son, Fred Jr., while his young cousin Ed Pimentel peers from the porch around 1936. By the 1930s, Filipino families began renting homes in an area bound by Broadway Avenue, Jefferson Street, and James Street. This remained a Filipino enclave until Seattle University purchased their homes to build Campion Tower and expand the campus. (Courtesy Diana Floresca Kelting and FANHS.)

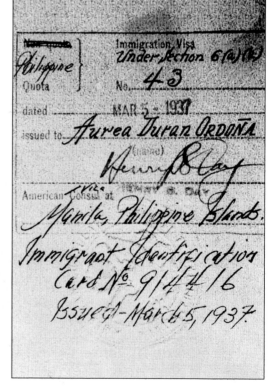

When Congress passed the Tydings-McDuffie Act in 1935, Filipinos in the United States were no longer American nationals who could come to this country without restrictions. They were now aliens, and the new immigration quota was 50 a year. When Aurea Duran Ordona came to the United States in 1937, she was issued the visa quota No. 43. This left seven others to come that year. (Courtesy Nancy Ordona Koslosky and FANHS.)

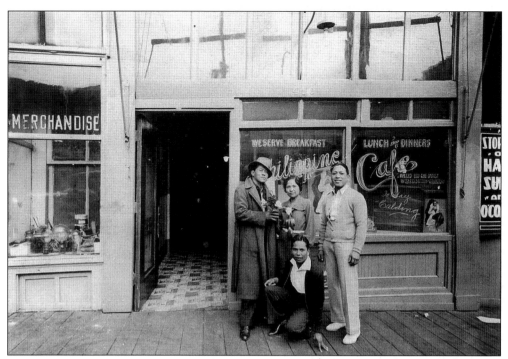

In the mid-1930s, Valeriano and Bibiana Laigo owned the Philippine Café in Chinatown. Restaurants such as these provided home-cooked meals and meeting places for Filipino men living in Chinatown. After the death of her husband, Bibiana continued to run the restaurant for another year. Note the wooden sidewalks, which actually fronted the third floors of buildings along an elevated Fifth Avenue South. (Courtesy Dorothy Laigo Cordova and FANHS.)

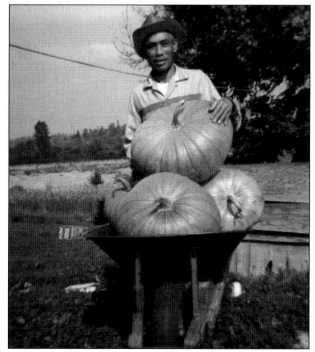

In the early 1940s, Marceliano Balatico and his brother Andrew bought a farm in what is now Bellevue. In 1975, he began to farm alone and harvested crops such as corn, pumpkins, and blueberries. In later years, hundreds of east side families came to his farm to search for the perfect pumpkin. (Courtesy Nora Balatico.)

The children pictured above, all members of pioneer Filipino families, attend a *c.* 1939 party hosted by the Beltran family. From left to right are (seated) Dolores Estigoy, Dolores Domingo, and Tina Beltran; (standing) Albert Acena, Aurelio Simon, Cookie Delma, Jimmy Beltran (holding sister Tina's hands), unidentified, and Dolores and Carmen Delma. (Courtesy Jimmy Beltran and FANHS.)

Several Filipino families lived in an apartment on the corner of East Jefferson Street and Twelfth Avenue around 1935. Jimmy Beltran poses in the doorway of his home with a metal army hat perched jauntily on his head. The eldest of three children, he grew up and went to schools in what became known as Seattle's Central Area. (Courtesy Jimmy Beltran and FANHS.)

Attending Albert Mendoza's backyard sixth birthday party in 1938 are, from left to right, Christine Amado; Loretta Pimentel; Albert, Eddy, and Toto Pimentel; and Sonny Floresca. As more families moved here, this neighborhood eventually became very Filipino—known for parties and the fighting cocks surreptitiously raised in a backyard. The children usually attended St. James Cathedral School. (Courtesy Diana Floresca Kelting and FANHS.)

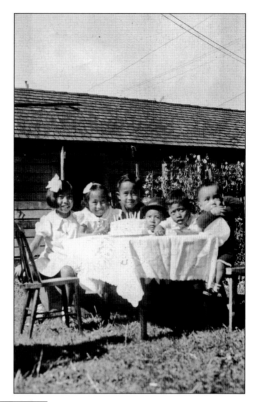

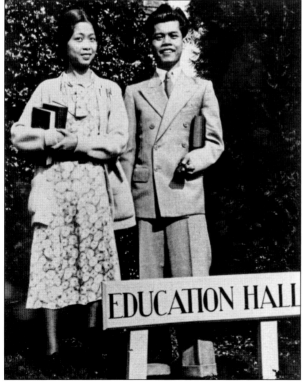

When Belen de Guzman attended the University of Washington, she was one of only three Filipina coeds at the school. She graduated with a degree in home economics in 1938. Belen had a sense of history when she attended Seattle College (later University) the year it became the first Jesuit college in the world to have a coed student body. This image is dated about 1935. (Courtesy Belen Braganza and FANHS.)

Vincent Flor (pictured around 1935), second in his family to come to America, arrived in 1932 to finish his education. In 1940, he received a bachelor of science degree from the University of Washington. While attending grad school, he worked at Providence Hospital, where he met his future wife, Louise Smith. At the time of his death, they had been married for 61 years. He retired from NOAA in 1975. (Courtesy Bob Flor and FANHS.)

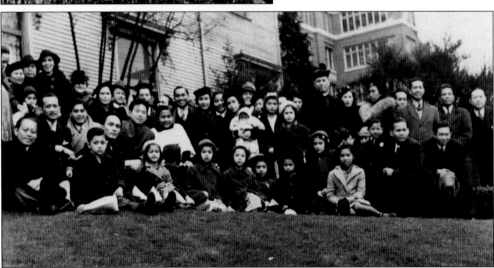

The Filipino Catholic Club began in the 1920s by some early Filipinos and Louis Esterman, a lawyer who helped purchase a clubhouse next to Maryknoll Church. This clubhouse served the spiritual and social needs of young immigrants and also housed students. In 1938, Fr. Pedro Monleon was assigned to tend to the spiritual needs of Filipino Catholics. Parishioners are gathered outside the church around 1939. (Courtesy *Filipinos: Forgotten Asian Americans* by Fred Cordova.)

When Father Monleon, a professor in philosophy at Seattle College, came to Seattle, he reached out to Filipino families, many who had left the church. This first communion group included children of early immigrants, including, from left to right, Donna Resos, Beverly Corpuz, Gloria MaYumul, Dolores Delma, and Bibiana MaYumul here around 1940. (Courtesy *Filipinos: Forgotten Asian Americans* by Fred Cordova.)

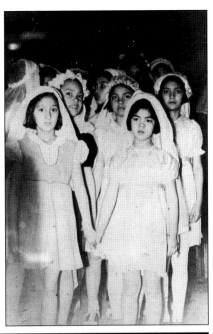

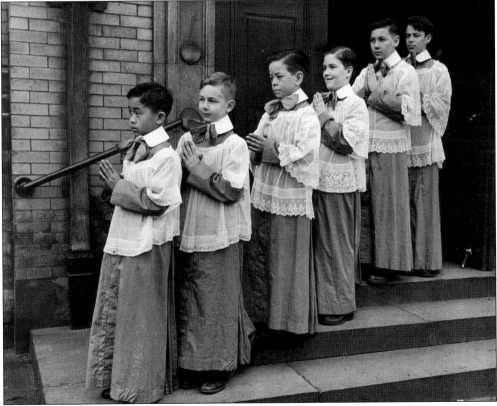

Altar boys lining up on the side of the church were also students of St. James Cathedral School around 1940. Filipinos were Albert Mendoza, far left, and John Duyungan, third from left. (Courtesy Mia Mendoza and FANHS.)

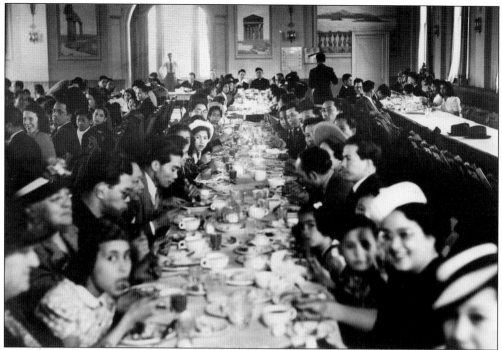

To accommodate the large number attending the annual Filipino Catholic Club Easter breakfast, it was held at the Casa Italiana Auditorium. This 1939 event was presided over by Father Monleon and Fr. Leo Tibesar, pastor of Maryknoll Church. (Courtesy *Filipinos: Forgotten Asian Americans* by Fred Cordova.)

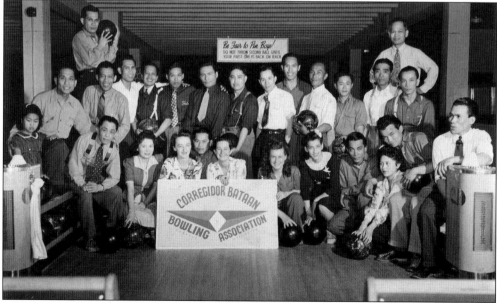

Filipino men engaged in different athletic activities, such as tennis, swimming, and bowling. The community had a small bowling league that lasted over 25 years. Members of the Corregidor Bataan Bowling Association pause for a group photograph; among them is Henry Gamido Sr. (second from left) with arm around his daughter, Marian. (Courtesy FANHS.)

Queen Connie Camposano (second row, center) on the Filipino Community Float in Seattle's 1939 Fourth of July parade is surrounded by her court: from left to right, (first row) Adela Adriatico, Juanita Mendoza, and Dolores MaYumol; (second row) Anita Villar, and Hyacinth Camposano. With the exception of Anita, all were second-generation Pinays (Filipinos born in America). (Courtesy FANHS.)

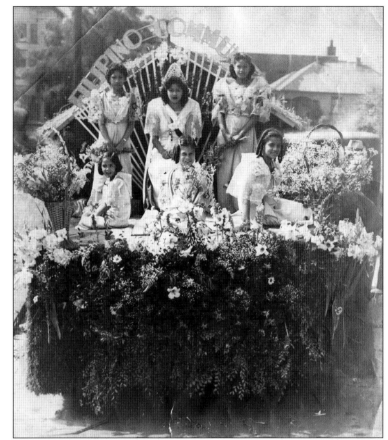

The 1938 Community Queen Gloria Aurelia stands in front of the family home with her mother and two friends, Pio Laigo (far left) and Boni Hipol (far right), around 1939. Mrs. Aurelia, a Puerto Rican, married her Filipino husband in Hawaii. (Courtesy FANHS.)

Bibiana and Mike Castillano (far left) entertain Mr. and Mrs. Yuponco (middle) and Mr. and Mrs. Guerrero (right) from San Francisco at a c. 1940 picnic along Lake Washington. The Yuponco and Guerrero sisters grew up with Bibiana in Naguilian, La Union. Mercer Island in the background is still wooded, with homes mostly along the island shoreline. (Courtesy FANHS.)

Shortly after their wedding in 1938, Marjorie Cabal and Francisco Arcala LaGasca pose on the front porch of their home in Tacoma, Washington, where they raised three children. Francisco came to America in the late 1920s. After Francisco died, Marjorie remarried, and the family moved to Stockton, California. (Courtesy Mel LaGasca.)

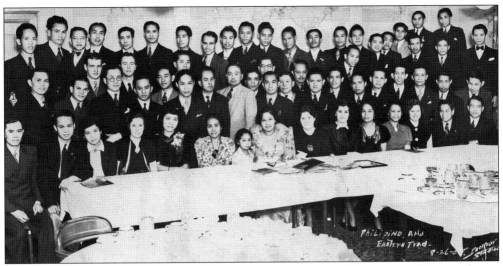

By the mid-1930s, some Filipinos were beginning to invest in small businesses. Above is a dinner meeting around 1939 for stockholders of the Filipino and Eastern Trading Company, which imported quality Philippine-made articles and opened a dry goods store in Seattle in 1940. Since the main office was in Baguio, Philippines, the company closed for good when World War II began. (Courtesy Ignacio Pimentel and FANHS.)

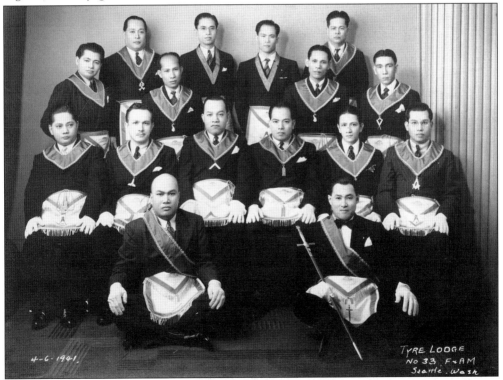

This 1941 photograph of Tyre Lodge No. 33, F&AM, included past and future Filipino Community presidents. Pictured are Frank Ortega (first row, far right), Rudy Santos (second row, far left), Guido Almanzor (second row, second from left), Union president Prudencio Mori (third row, second from left), and treasurer Ferdinand Ferrera (third row, extreme left). (Courtesy FANHS.)

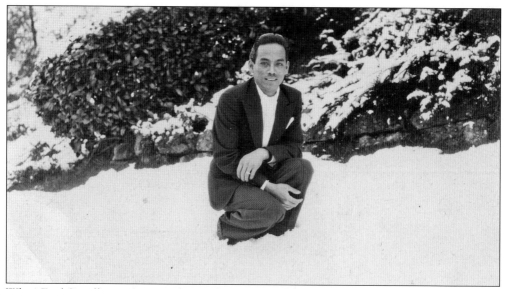

When Fred Castillano immigrated to America in 1929, he intended to go to school. However, the Great Depression prevented him from following his dream. He became a houseboy and worked in California agricultural camps, Alaska canneries, and Seattle kitchens. Shortly after the dapper Fred posed in the fresh snowfall in Seattle around 1941, he enlisted in the U.S. Army and later became part of the 1st Filipino Infantry in Fort Ord, California. (Courtesy FANHS.)

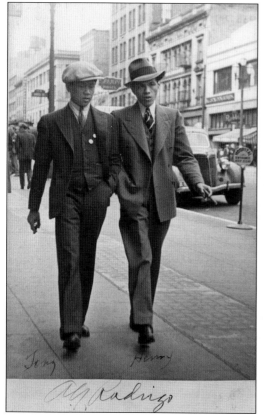

Tony Rodrigo, a founder and officer of the Alaska Cannery Union, first worked on the railroads and lived in boxcars with other laborers repairing railroad ties in Montana. As Tony (left) and Henry Arviso stroll in downtown Seattle around 1939, America is slowly climbing out of the Great Depression, but the war in Europe has the nation on edge. (Courtesy FANHS.)

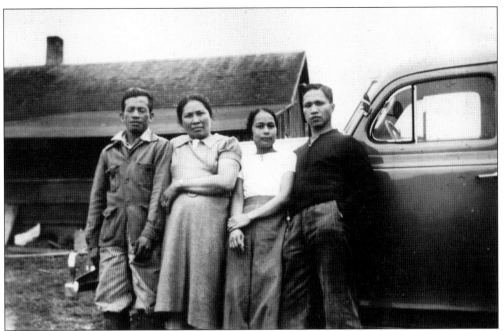

Leon and Magdalena Laigo (left), farmers in the Green River Valley, visit with city visitors, her brother Saturnino Mendoza (right) and his wife, Juliana, around 1940. During the 1930s, unable to own property, Filipino immigrants were tenant farmers of white landowners or laborers on farms owned by Japanese Americans. (Courtesy Mia Mendoza and FANHS.)

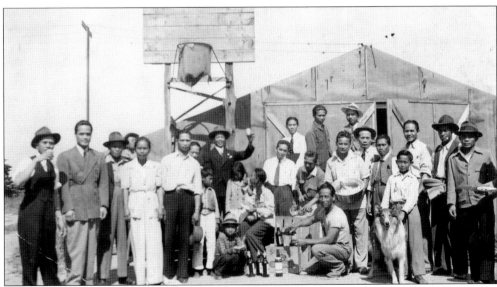

Seattle Filipinos often visited relatives or town mates farming in the Green River Valley. This *c.* 1940 group, all from the town of Bauang, La Union, attend a party in Auburn, which usually featured *lechon* (roast pig) or *calding* (goat), a special delicacy for Ilocanos, people from the northern Lugon in the Philipines. (Courtesy Mia Mendoza and FANHS.)

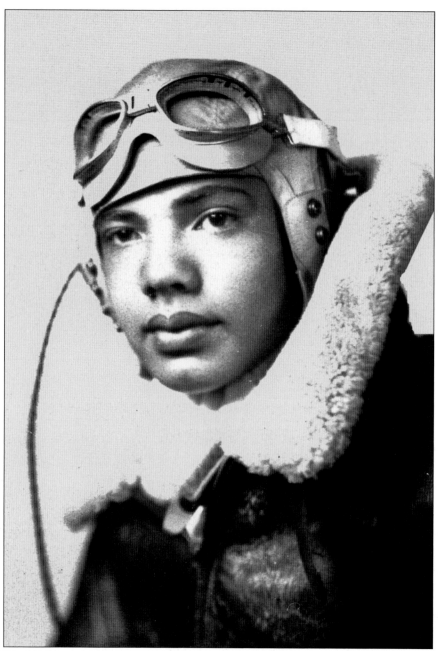

José Rizal Elfalan was the son of a Filipino immigrant who joined the U.S. Navy to become an American citizen. His mother was the granddaughter of a Confederate captain who was at Appomattox when the South surrendered during the Civil War. During World War II, José trained as a pilot for 477th Bomber Group of the Tuskegee Airmen. After the war, he became an aeronautical engineer and was the third African American engineer hired by the Boeing Company in Seattle. José helped design aircraft and aerospace projects, including the first Moon Probe and the AWACS spy plane projects. As chairman of SAE International, he represented Boeing and the United States, implementing worldwide metric standards. Engineering papers he wrote are currently stored in the Smithsonian. (Courtesy David Elfalan.)

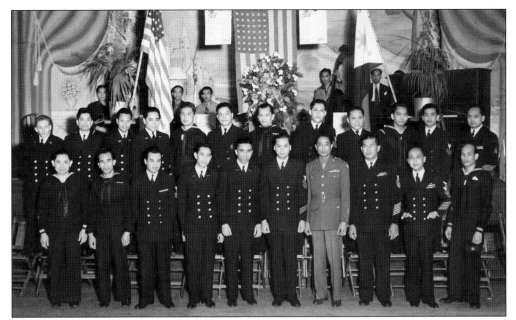

From the early 1900s to 1940, thousands of Filipinos enlisted in the U.S. Navy in the Philippines and were stationed in ports around the country. When World War II began, other Filipinos in America joined the U.S. Army, Navy, MSTS (Military Sea Transport Service), and the Navy. During a Filipino community dance at Seattle's Finnish Hall, some servicemen pose before the stage. (Courtesy FANHS.)

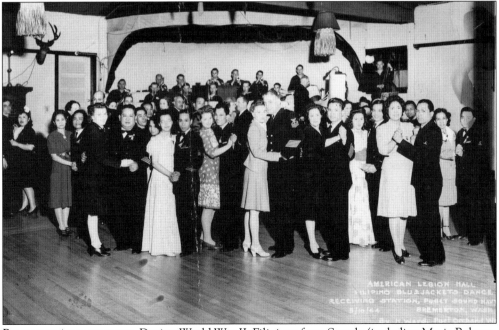

Bremerton is a navy town. During World War II, Filipinos from Seattle (including Maria Beltran, Matilde Rallos, and Helen Bigornia) attended a dance sponsored by the Filipino Blue Jackets, Receiving Station, Puget Sound Navy Yard. It was held at the American Legion Hall in Bremerton, Washington, on May 14, 1944. (Courtesy Jim Beltran.)

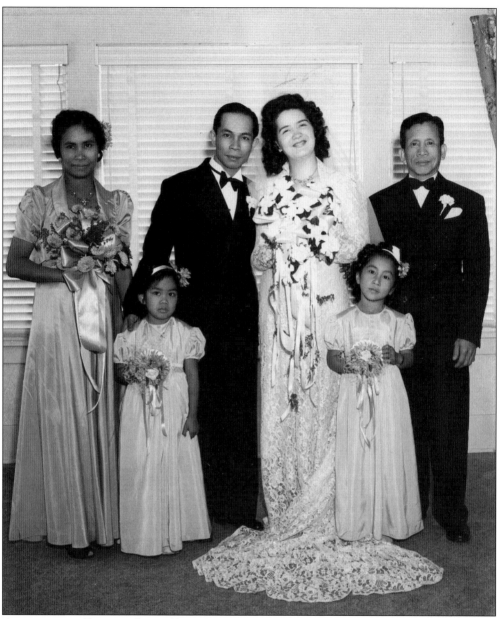

As men went off to war, the number of marriages increased. In 1944, Clara Jane Wise married Lean Laigo, a merchant marine. The wedding party included his sister-in-law Genevieve Ordona Laigo (left) and cousin Leon Laigo (right). The flower girls were nieces Nancy Ordona and Diana Floresa. (Courtesy Barbara Laigo Martin.)

Three

GROWING COMMUNITIES

World War II brought many changes. Thousands of Filipino men in America enlisted in the U.S. Army 1st and 2nd Filipino Infantries, which trained in California army posts. When training was completed, they could become American citizens. Uncles in the U.S. Army sent their families large photographs showing hundreds of soldiers swearing allegiance to the United States. Their citizenship allowed them to bring their young war brides to America after the war ended.

On the home front, Filipinos worked in shipyards and war plants, in vital food production in Alaska salmon canneries, and on farms. On Bainbridge Island, some took over farms when Japanese bosses were relocated to camps. After the war, they returned farms to the original owners. Some Filipino farmers married young Canadian Indian women who came to pick berries.

After the war, descendants of American servicemen, businessmen, and civil employees who remained in the Philippines after the Spanish American War began to arrive. Before the Philippines gained independence in 1946, many Bataan-Corregidor survivors who chose to remain with the U.S. Army were granted American citizenship and brought their families to America. Navy recruits from the Philippines were stationed at Seattle's Sand Point and the Bremerton Naval Base. During the Korean War, Filipino military populations grew around Fort Lewis and Whidbey Island. Exchange workers and students remained here by marrying old-timers—and the community continued to grow.

The arrival of the Philippine Consulate added a new dimension to the social life of Filipinos once content with weekend dances and occasional banquets. Older immigrants had become American citizens, but many viewed the Philippines as their "homeland."

Not so for their American-born children, who saw their future in this country—despite discrimination. In 1957, a group of young second-generation Pinoys and Pinays started the Filipino Youth Activities of Seattle (FYA). Its simple premise was to provide "wholesome leisure time activities for Filipino American youths." The FYA would promote the spirit of volunteerism.

In 1965, after years of renting different halls for events, the Filipino Community of Seattle purchased a bowling alley for its community facility. Times were changing, but hectic times were still to come.

After the Spanish-American War, a number of American servicemen, civil servants, and businessmen married Filipinas and remained in the Philippines. When World War II ended, some descendants came to the United States. These "white Americans" were Americans through their fathers or grandfathers but Filipino in their hearts. Among the first to arrive in Seattle were Anthony and Emily Ogilvie (above) and their three children. (Courtesy Anthony Ogilvie.)

In an oral history, Rose Lampe recalled her family's journey to America at the end of World War II. Mothers had to keep their babies silent because, if they cried, Japanese submarines still prowling the Pacific Ocean could track their transport ship's whereabouts. They were not safe until they passed Australia. In the fall of 1945, ten members of the Lampe family arrived in America. (Courtesy Marlene Edwards.)

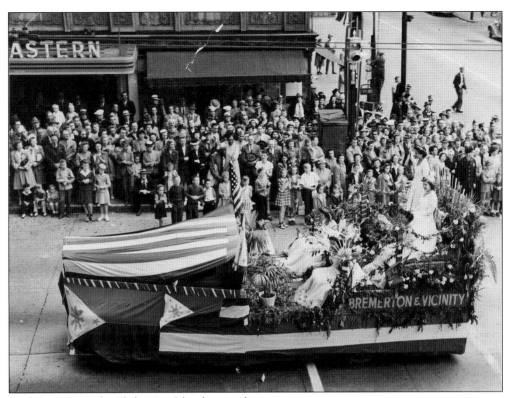

On July 4, 1946, the Philippine Islands gained its independence from the United States. It was now the Republic of the Philippines. Filipino communities throughout America celebrated this event with banquets, coronations, and participation in local parades. The Filipino Community of Bremerton and Vicinity sent its royal court and float to Seattle's Fourth of July parade. (Courtesy FANHS.)

Most war brides were Visayan and their husbands Ilocano. Since many were neighbors in the Rainier Vista Projects, they developed a close-knit social and support group that lasted for years. They pose with their children—some born in the Philippines. The families shown are the Angeles, Mendoza, Sabado, Sumaoang, and Zapata families around 1949. (Courtesy Betty Sumaoang.)

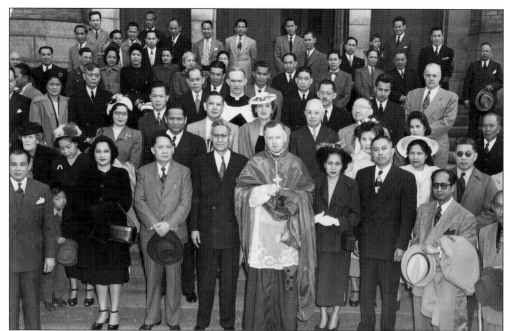

In 1948, the new Philippine government created a consulate office in Seattle, which then had the third-largest Filipino population on the mainland. A special mass celebrated by archbishop Thomas Connolly was attended by Philippine consul general Tomas Regala (left of Connolly), consul and Mrs. Pedro Ramirez (right of Connolly), and members of the community in Seattle. (Courtesy FANHS.)

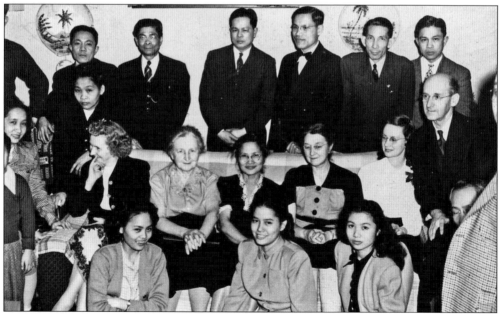

As the Philippines was a colony of Spain for 350 years, most Filipinos were Catholic. However, under the United States, membership in Protestant churches grew. The Filipino Community Methodist Church was a close-knit congregation. In this *c.* 1948 photograph, they enjoy an evening of fellowship. (Courtesy Ruth Vega.)

Although consulates usually deal with trade between their country and the United States, Philippine consulates often interacted socially with local Filipinos. On July 22, 1948, consul Pedro Ramirez hosts a cocktail party at his home for the leaders of different Filipino community organizations. This began a new era of social interaction with officials of the new Philippine government. (Courtesy FANHS.)

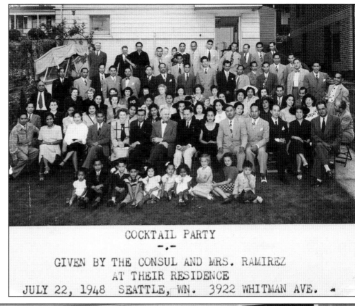

COCKTAIL PARTY
-.-
GIVEN BY THE CONSUL AND MRS. RAMIREZ
AT THEIR RESIDENCE
JULY 22, 1948 SEATTLE, WN. 3922 WHITMAN AVE.

Under the leadership of Rev. P. J. Daba, the Filipino Community Methodist Church just off Twelfth Avenue and East Terrace Street served Filipino Protestants for many years. By the late 1960s, increased immigration brought many new members, and the congregation began to make plans for a larger church, later built on south Beacon Hill. (Courtesy FANHS.)

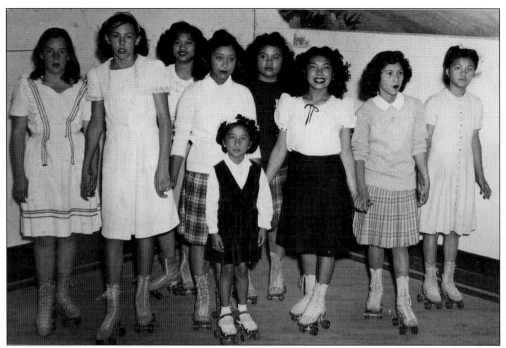

By the 1940s, second-generation Filipino Americans had become more Americanized. For her 17th birthday in 1947, Christine Amado (second from right) hosted a skating party. Attending were, from left to right, two unidentified, Dolores Estigoy, Dolores Domingo, Evelyn Gaudia, Anita Villar, Nina Gaudia, and standing alone in the front row (center) is Diana Floresca. (Courtesy Diana Floresca Kelting and FANHS.)

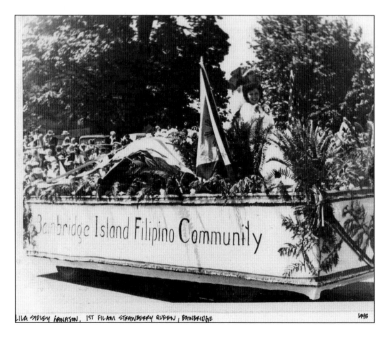

LILA SIDLEY LAWASON, 1ST FILAM STRAWBERRY QUEEN, BAINBRIDGE

Bainbridge Island Japanese farmers taught Filipinos to grow and care for strawberries. When Japanese were sent to concentration camps, they entrusted farms to their workers. After the war, many Filipinos bought their own farms. In 1948, Lila Sidley Lawason became the first Filipino American Strawberry Queen of Bainbridge Island and rode a float entered by Filipino strawberry farmers. (Courtesy Joann Oligario.)

48

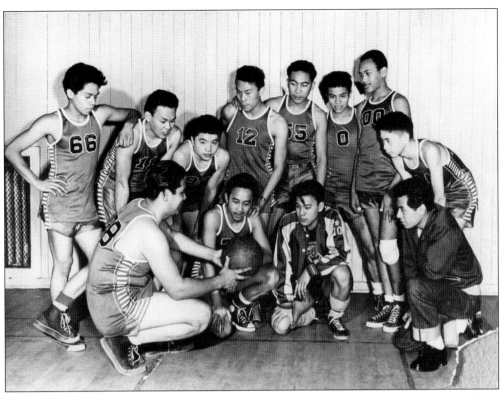

In the 1950s, there was a wellspring of youth activities for Maryknoll Parish's Filipino Catholic Youth with programs like athletics (above) and religious pageantries (below). The basketball Crusaders included a family roster of the names Del Fierro, Mamon, Caasi (or Lagasca), Gaudia, Beltran, Cantil, Mendoza, Reyes, Santos, San Gabriel, and "Honorary Filipino" Bob Murray. The team played league games at the Japanese Buddhist Temple gym. (Courtesy Fred Cordova.)

In 1949, the Filipino Catholic Youth presented a nativity tableau as part of the Maryknoll Parish Christmas activities. Cast members were Adela Adriatico as Mary, Al Acena as St. Joseph, and assorted angels— Adelia Pagaran, Marian Gamido, Angie Bernardino, and Helen Mamon. Background music was provided by the offstage FCY choir. (Courtesy Dorothy Cordova.)

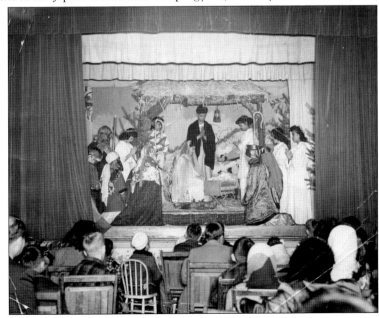

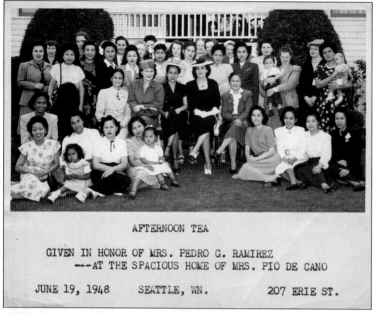

AFTERNOON TEA

GIVEN IN HONOR OF MRS. PEDRO G. RAMIREZ
---AT THE SPACIOUS HOME OF MRS. PIO DE CANO

JUNE 19, 1948 SEATTLE, WN. 207 ERIE ST.

This c. 1948 afternoon tea in honor of Mrs. Pedro Ramirez (center, with white hat), given by Mrs. Pio (Luvi) DeCano (second row right, holding baby) at her home, shows some Filipina women were gradually assuming American social customs. Guests included pioneer Filipinas, new immigrants, and the Caucasian wives of Filipino "old-timers." (Courtesy Diana Floresca Kelting.)

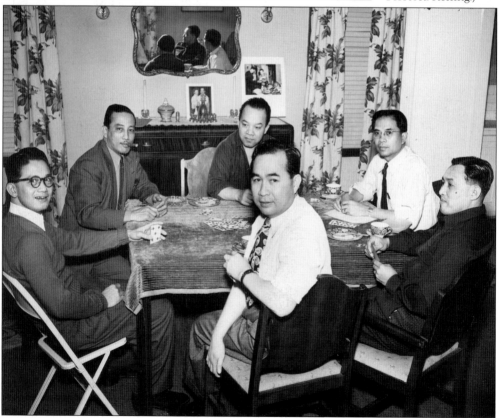

Guido Almanzor (center, back row) often invited friends to spend an evening playing cards—especially rummy. Seated around the table were Frank Ortega (right front), Prudencio Mori (back right), Joe Camarillo (back left), and two unidentified. (Courtesy FANHS.)

50

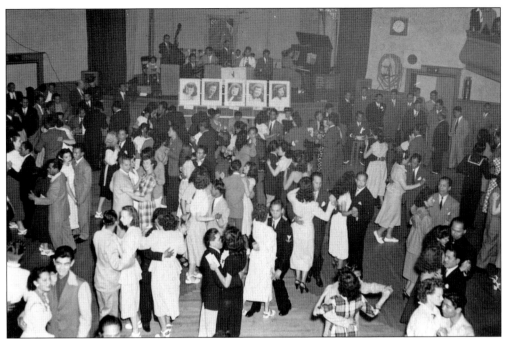

To raise funds and celebrate Philippine Independence, Filipino communities held queen contests whereby the winner was the candidate selling the most tickets. This photograph shows the crowd during the Filipino Community of Seattle's last tabulation dance, held in Washington Hall in 1948. (Courtesy FANHS.)

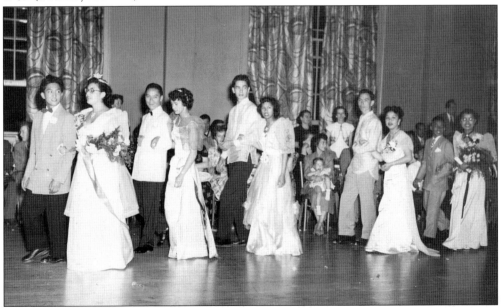

Queen Patricia Camposano and her escort, Val "Sonny" Laigo, lead the c. 1950 coronation march with Princess Lita Duyungan and her unidentified escort, Helen Mamon with Glenn Orkiola, Nina Gaudia and Andy Fleming, and Herminia DeCano with Pio DeCano Jr. For many years, the Filipino community held these events at the Seattle Chamber of Commerce Auditorium. (Courtesy Pio DeCano Jr.)

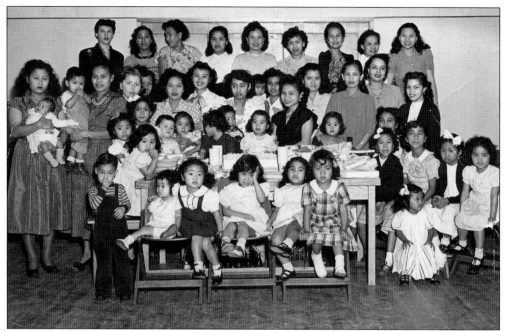

During the 1950s, Filipino communities grew through immigration and the births of babies of war brides and second-generation Pinays. Filling many Saturdays were countless showers and birthday parties, such as Betty Sumaoang's. These events, often held at the Rainier Vista social hall, also were social outlets for the young wives. (Courtesy Betty Sumaoang Ragudos and FANHS.)

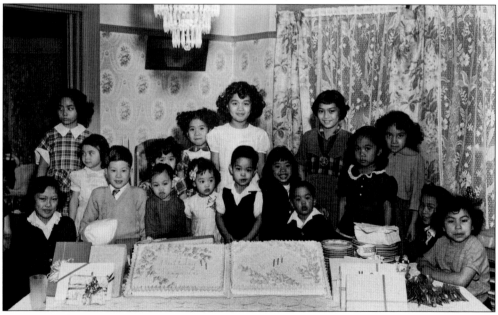

Danny Mendoza and his sister Tania celebrate their birthdays at their grandma Juliana Mendoza's house around 1953. Their aunt Mia Mendoza is directly behind them. Other young guests are Mary and Jeannette Castillano, Linda and Marily Laigo, Betty Sumaoang, Ernie and Annette Mamallo, Josie and Elizabeth Ordonia, Roberta Pimentel, and Lena Osoteo. (Courtesy Mia Mendoza and FANHS.)

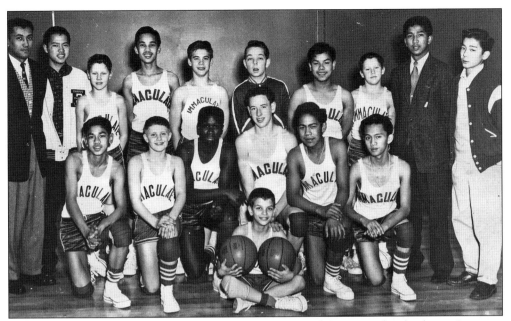

By the late 1950s, the Immaculate Conception Grade School was multiracial with Filipino, Japanese, African American, and white students. The 1956 basketball team was the CYO (Catholic Youth Organization) champion. Coached by Ben Laigo (second from right), who was assisted by Leroy (second row, left) and Al Capili (second row, second from left) and Joe Matsudaira (far right), a few of the team members were Edri Beltran, Charles Maxie, Adolfo Salazar, Michael Hall, and Tony Brillantes. (Courtesy Ben Laigo.)

After World War II, Sarah Roberson, a mestiza from the Philippines, married Fernando Martinez, an "old-timer" who came to America for an education and graduated with a political science degree. In 1953, they opened the Manila Café—a Chinatown fixture for years—which had three locations. First was the corner of what is now Hing Hay Park, then one block south to Maynard Avenue, and finally to West Seattle. This image is from around 1960. (Courtesy Sandra Martinez.)

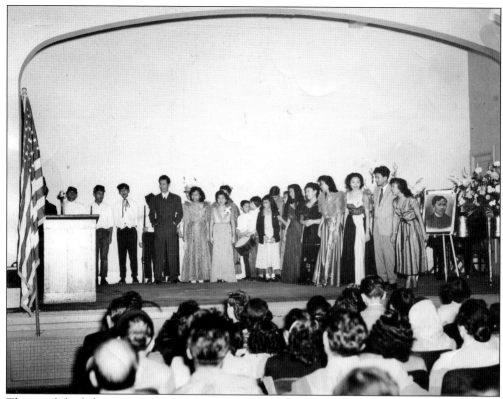

The youth had their say in producing a Rizal Day play to commemorate the execution of the iconic Philippine hero-martyr Jose Rizal. Following the traditional script, the play had some foibles, which brought "irreverent" smiles by some in the cast during the execution scene. This caused a community newspaper editor to write a scathing review. The actors and actresses all survived, including the playwright. This image was taken in 1950. (Courtesy FANHS.)

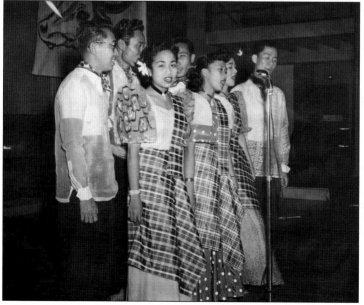

University of Washington students proudly show their Philippine pride with songs and folk dances in 1954. Although the 100 or so were mostly undergraduates, there was also the beginning of a growing number of graduate students. The Filipino student body was predominantly from the Philippines, but after graduation, many remained to become pillars in the Seattle Filipino American community. (Courtesy FANHS.)

Seattle University not only got a Philippine touch but a Filipino American identity from members of the Pinoy Club, whose students, mostly undergraduates, came from Seattle as well as Alaska and Guam. Their presence on campus was very pronounced during homecoming celebrations, when the Pinoy Club introduced *lumpia*—a Philippine pastry—and unusual Val Laigo displays that would win the top exhibit awards. This image was taken in 1954. (Courtesy Fred Cordova.)

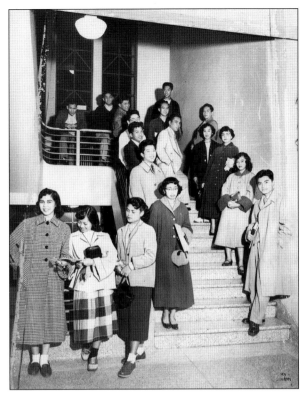

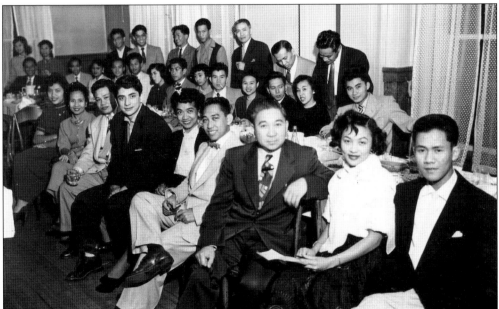

Philippine consul and Mrs. Hortencio Brillantes host a *c.* 1954 dinner at a Chinese restaurant for college students from Seattle University and University of Washington. Their three oldest children attended Seattle University and participated in cultural events at the University of Washington. Seated in the first row, third from right, is *Filipino Forum* editor-publisher Victorio A. Velasco, who was also a noted poet. (Courtesy FANHS.)

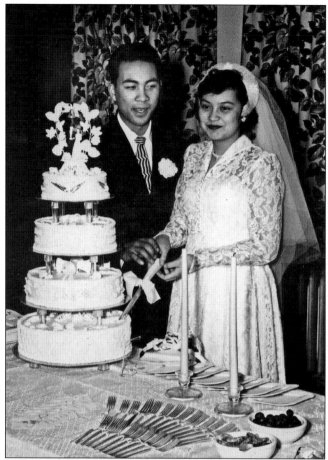

Seattle University students Jim Beltran of Seattle and Eloisa Castro of Bremerton were married in 1953. After Jim served in the U.S. Air Force in Fairbanks, Alaska, the couple returned to Seattle to raise their five children. Jim was the first Filipino police officer in the Pacific Northwest. This image is from around 1953. (Courtesy Eloise Castro Beltran Hartman.)

While the crowd looks on with glee, Lois Balasoro grabs the tossed bridal bouquet during the wedding reception of Dorothy and Fred Cordova in the Maryknoll Church Auditorium in 1953. By the early 1950s, many second-generation American-born Filipinos were marrying and raising their own families. (Courtesy Dorothy Cordova.)

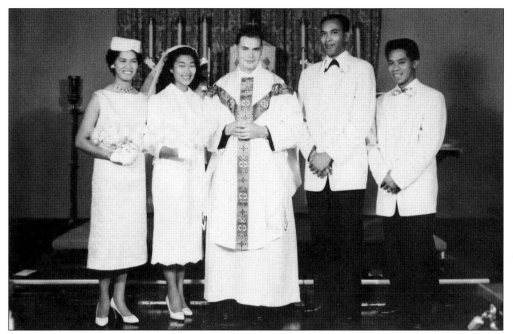

Marian Gamido and Bob Murray wed in St. Teresa's Church attended by best friends Helen Mamon Laigo (left) and Bill Mamon around 1957. The young couple met when both were members of the Filipino Catholic Youth club at Maryknoll Church. They raised six children in Seattle. (Courtesy FANHS.)

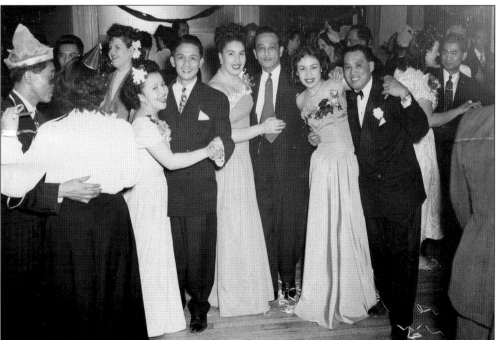

Filipinos loved to dance, and New Year's Eve parties were the biggest galas, with people dressed up and having a great time. Frank Ortega (front right), his date, and friends enjoy the music while waiting for the New Year to roll in around 1952. (Courtesy FANHS.)

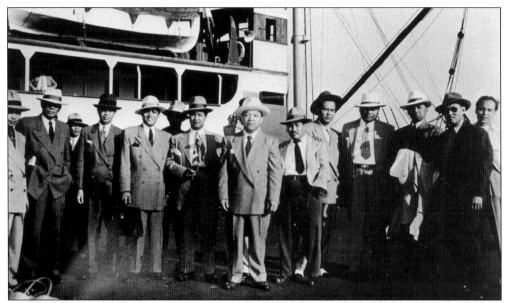

Although they look as if they are going to a social event, these Alaska cannery officers are at the dock to send off a boatload of cannery workers to Alaska around 1951. In a few years, all workers would travel by plane. Among the officials on the dock are, from left to right, two unidentified, Prudencio Mori, Gene Navarro, unidentified, Guido Almanzor, unidentified, Rudy Abella, Pio DeCano, unidentified, Frank Ortega, and Ponce Torres. (Courtesy FANHS.)

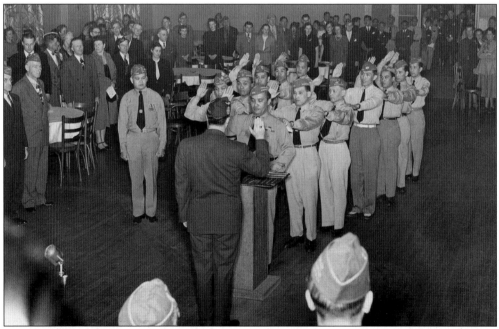

Seattle Filipino American World War II veterans of the U.S. Navy, Coast Guard, Air Corps, and Army are sworn in as members of the Veterans of Foreign Wars' Seattle Post 6599. Before the war, most men worked in agricultural fields, canneries, kitchens, hotels, and other menial jobs. Some were students. After soldiers trained in California for the 1st and 2nd Filipino Infantry Regiments, they were shipped overseas to help liberate the Philippines. (Courtesy FANHS.)

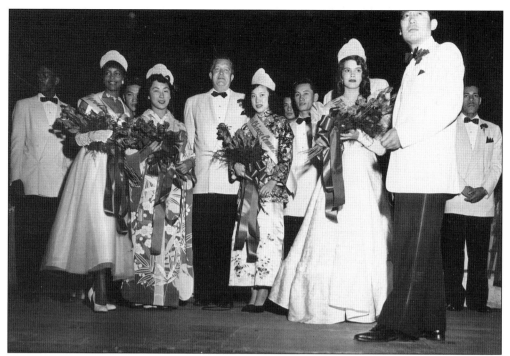

In the early 1950s, the Jackson Street Community Council held an International Festival in Chinatown every summer. A highlight was the crowning of queens from the African American, Chinese, Japanese, and Filipino communities. The 1952 Filipino queen was Rosita DeLeon of Tacoma (second from right), who went on to become the first lady-in-waiting in the Seafair Queen contest. (Photograph by Al Smith, courtesy FANHS.)

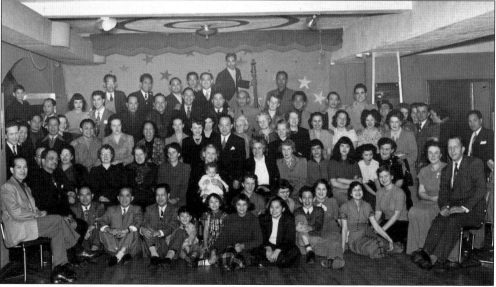

This party in a popular Chinatown nightclub was probably to celebrate the birthday or baptism of the baby held by its mother in 1951. Sponsors (or grandparents) must have been Mr. and Mrs. Guido Almanzor (directly behind the mother). Please note that most families in the region were mixed at that time. (Courtesy FANHS.)

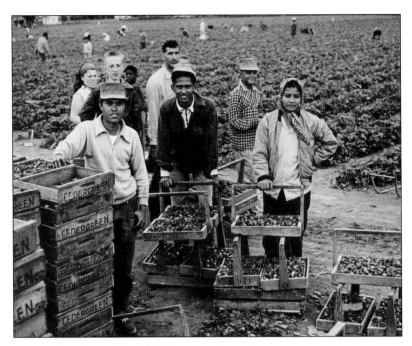

In a memo, Matilde Mina (far right) noted that on that day in 1958, there were 500 pickers gathering strawberries at the Mina farm in Puyallup. She wrote, "It was a great day for all of us. Tons and tons of berries delivered to the cannery—Cedargreen." (Courtesy Matilde Mina and FANHS.)

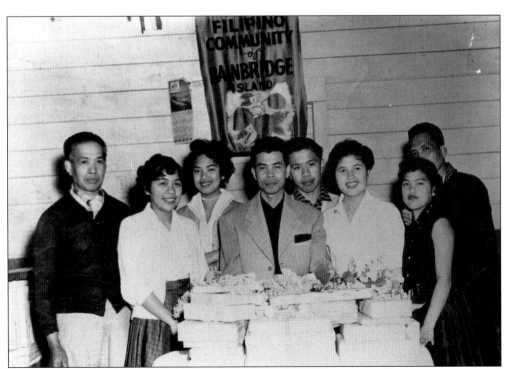

The Filipino Community clubhouse on Bainbridge Island was placed on the National Register of Historic Places on March 20, 1995. Formerly a packing shed for strawberry farmers, it was gradually remodeled by the community so it could serve as a gathering place where they could hold dances and other special events. (Courtesy Joan Oligario.)

In the 1950s, Philippine consul Irineo Ibanez began a loose-knit organization of Filipino American communities throughout the Pacific Northwest. Patricia Barrios attends one of their social functions in a Seattle hotel. At one time, her father, Vincent Barrios, was president of the Filipino Community of Bremerton and had been a leader in that city since the mid-1930s. (Courtesy FANHS.)

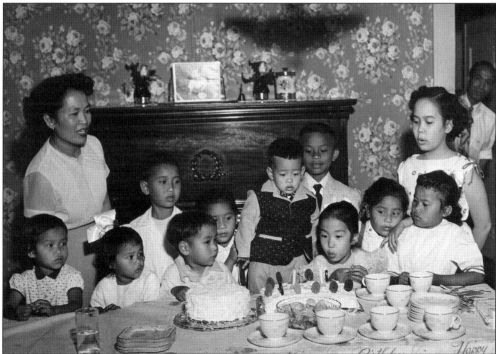

While mother Dora Tamayo, a schoolteacher who came from Pangasinan, watches daughter Josephine blow out candles, young relatives and friends anticipate eating the birthday cake around 1959. Most young guests—Jimmy and Fred Dimalanta and Barbara Posadas—are children of immigrants who also came from Pangasinan. (Courtesy Josephine Tamayo.)

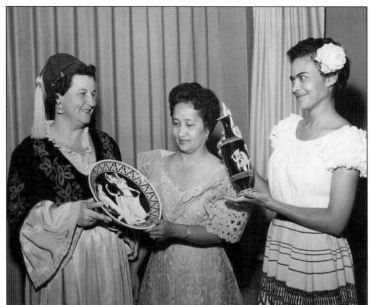

Flora Escame (center) was the first known Filipina PTA president in Seattle. She was active in her church, YWCA, United Good Neighbors, the Atlantic Street Center, and other civic organizations. During an international cultural event around 1953, she admires a Greek serving dish. (Courtesy Pio Escame Jr. and FANHS.)

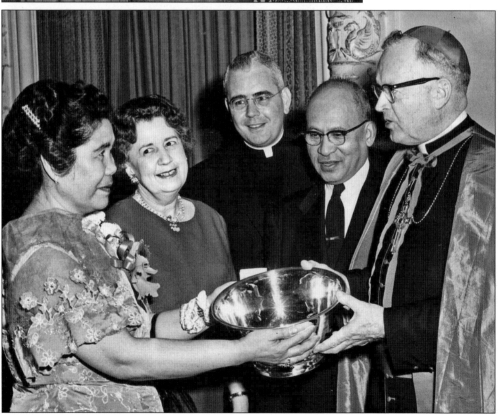

Maria Beltran (far left) receives an award around 1955 from archbishop Thomas Connolly of the Archdiocese of Seattle for the many years the Beltrans cared for dozens of foster children. Looking on, from left to right, were a Catholic Charities social worker, Catholic Charities director Fr. Dennis Muehe, and Santiago Beltran. (Courtesy Jim Beltran.)

Diana Floresca (standing, left of center) presents a bouquet to 1958 Independence Day Queen Rosalie Mendoza, whose court includes, seated from left to right, Anita Agbalog, Teresa Cantil, Juana Martos, and Mel Caesar. Their escorts are, from left to right) Bill Pagaran, Harry de Lizo, Rick del Fierro, Joe Jainga, and Ben Singson. Young attendants in the first row are, from left to right, Danny Josue, Regina Consego, Marilyn Occasion, Kathy Occasion, Valerie Mendoza, and Randi Osoteo. Diana's friends are Eleanor Elefanio (standing far left) and Grace Misames (standing far right). (Courtesy FANHS.)

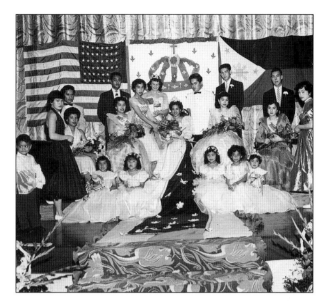

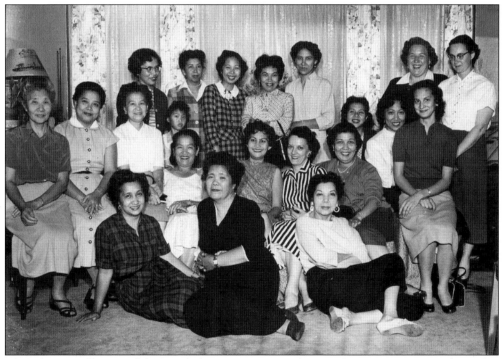

The Filipino Women's Club, founded in 1934, remained active for 70 years. Original member Maria Beltran (first row, center) hosts a group of newer members at her home around 1955. They are, Flora Escame (first row, left) and Naty Carlyle (first row, right); (second row) from left to right, Felicidad Acena, Virginia Cacabelos, Dionisia Acena, Dora Tamayo, Sophie Pulmano, Leona Balagot, Pauline Niaga, Irene DeLizo, Soling Aspiras, and Dolores Cantil; (third row) Elsie Anciano and daughter Susan, Phyllis Vining, Bening Flores, Christine Mamallo, Ruth Bacalzo, Ramona Carnaje, and Louise Flor. In later years, the Filipino Women's Club raised funds to give small scholarships to students. (Courtesy Jim Beltran and FANHS.)

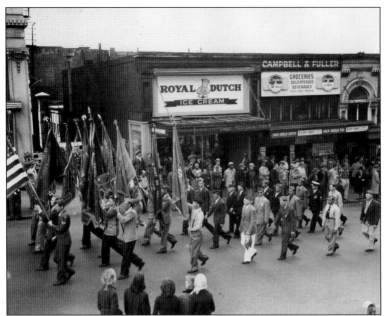

On a c. 1950 Veterans Day, this multiracial group of comrades, including Filipino Americans, head for the assembly area for a parade in downtown Seattle. Most Filipino Americans were World War II veterans and members of the Veterans of Foreign War members Post 6599 or the American Legion's Rizal Post. (Courtesy FANHS.)

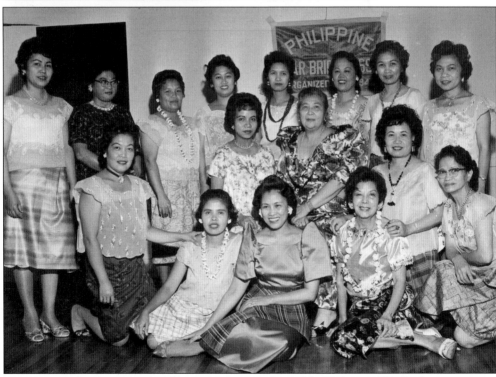

Twenty years after they arrived in America, many members of the Philippine War Brides organization had become productive members of the Filipino Community of Seattle. Some, such as, Naty Ruby Carlyle (first row, second from right), Coring Zapata (standing, fourth from left), Emma Lawsin (standing, far right), and Fanny Sumaoang (standing, second from right) were also members of the Filipino Community Council. This image is dated about 1967. (Courtesy Dolores Sibonga and the Filipino Forum.)

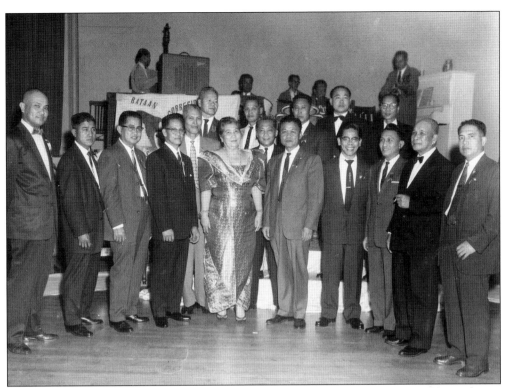

Consul Estela Sulit pays homage to Bataan-Corregidor survivors during their organization's event that brought together members living in the Seattle and Tacoma areas. Among the members are Capt. Lescum dela Cruz (far left), Maj. Urbano Quijance (right of Consul Sulit), and Felix Ramos (far right). (Courtesy Dolores Sibonga and the Filipino Forum.)

The most decorated Filipino World War II veteran hero, Jose C. Calugas Sr. of Tacoma, was conferred with the highest military award, the Congressional Medal of Honor "for bravery above and beyond the call of duty." Captain Calugas is personally cited by Pres. John F. Kennedy in ceremonies at Washington, D.C. (Courtesy FANHS.)

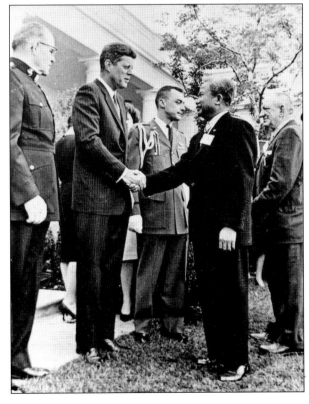

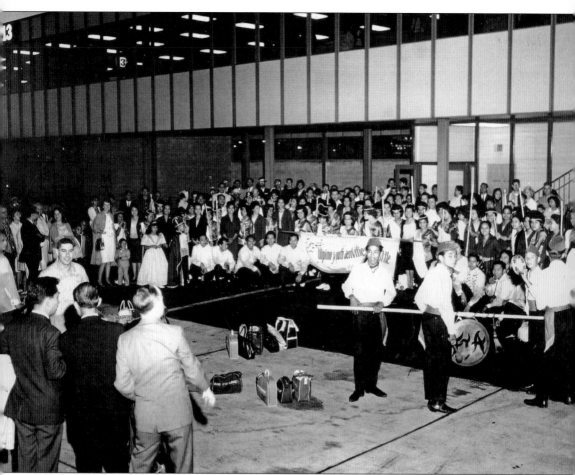

In 1963, when the Bayanihan Philippine Dance Company arrived from New York for its first performance in Seattle, they were met at the airport by Seattle's Filipino Youth Activities Princesa Drill Team and Cumbanchero Percusioneers. The renowned troupe members from the Philippines were intrigued by their young American hosts who wore Muslim dress. This began a friendship between the two groups which lasted for more than two decades. (Courtesy FYA.)

The Filipino Youth Activities Princesa Drill Team did not look like lovely swans but ducklings at their very first practice in 1959. However, 22 of the originals, called "Pajwelas," provided a winning marching tradition when they emerged from being plain grade-school pupils to beautiful performers, reflecting Philippine ethnic minority cultures with Indo-Malay, Hindi, and Latino variances. Succeeding Princesas, never older than 19, carried on the victoriously inimitable tradition. (Courtesy Fred Cordova.)

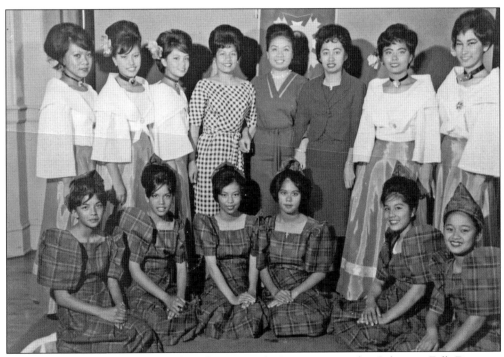

The oldest-standing segment of the Filipino Youth Activities was the Cabataan Folk Dancers, started in 1957 and performing throughout the West Coast. Philippine culture was shown in Muslim, Igorot, rural, and Spanish-influenced dances. Directorship passed from Flora ("Tiny") Consego to one of her charges, Betty Sumaoang Ragudos, an FYA tradition of generation leadership transference. This image was taken in 1967. (Courtesy FYA.)

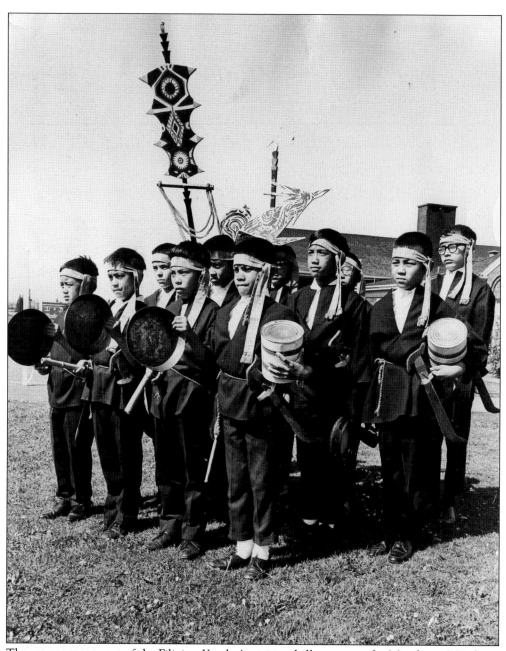

The youngest segment of the Filipino Youth Activities drill team was the Mandayan Marchers, boys from seven years old to the sixth grade. Wearing an ethnic tribal motif, *Mandaya* were armed with *kampilan* (wooden bolos). Their musical instruments were innovative fry pans turned into *gangsas* (a hand gong). Discovering their manly attributes gave them much bravado in drill competition. This image was taken in 1965. (Courtesy FYA.)

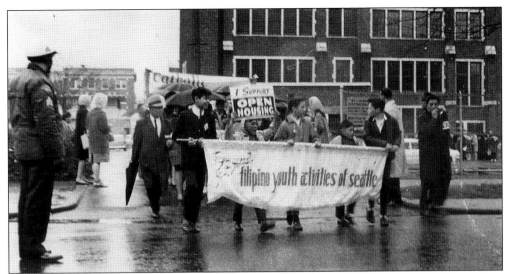

Leading with a Filipino Youth Activities banner, c. 1965 demonstrators from the Filipino American community begin their march through a brisk rain to encourage the Seattle City Council to legislate an Open Housing Ordnance to enable all racial minorities to live anywhere in the city's neighborhoods, according to their means and livelihood. Filipino Americans, like all minorities, had been ensconced in ghetto areas by unwritten real estate bans. (Courtesy Fred Cordova.)

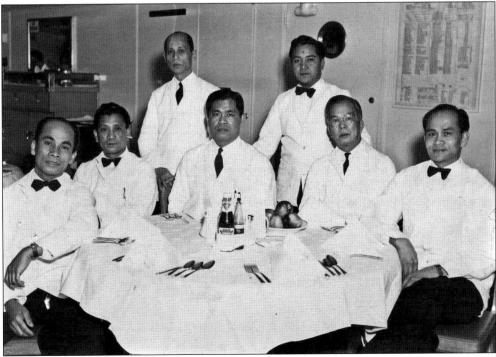

For years, the Military Sea Transport Service (MSTS) sailed between Seattle and Far East ports. Many Filipinos including those above were waiters serving meals for military personnel and families making trips across the Pacific Ocean. Some men married women they met in Japan, and eventually Seattle had a small and close-knit group of Filipino-Japanese families. This image is from around 1950. (Courtesy FANHS.)

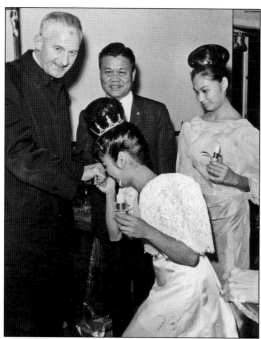

Seattle auxiliary bishop Thomas E. Gill is met by Filipino Community of Seattle president Urbano Quijance, Queen Maria Macahilig, and Princess Susan Carlyle before the blessing of the newly purchased Filipino Community Center in 1965. The structure, formerly a bowling alley in Rainier Valley, marks the first permanent home for the Filipino Community, planning for a permanent facility since the late 1920s. (Courtesy FANHS.)

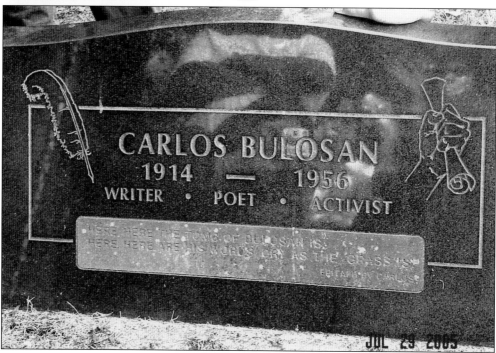

On Seattle's Queen Anne Hill in Mount Pleasant Cemetery is the humble grave site of Filipino America's literary icon, Carlos Bulosan. Although Bulosan's insightful writings and books covered life in the Philippines and the United States, Bulosan died in Seattle. His grave marker, made possible through efforts of University of Washington student Stan Asis and other Bulosan followers, reads, "Here, here the tomb of Bulosan is: Here, here are his words dry as the grass is." (Courtesy FANHS.)

Four

COMMUNITIES IN FLUX

By the early 1960s, America was undergoing great social changes. The civil rights movement led by brave African Americans spread through the country. Soon Chicanos, Native Americans, and Asian Americans sought social and economic equity. The fight to live anywhere in Seattle spurred the push for open housing.

In 1965, U.S. immigration laws were revised and the annual quota of immigrants from the Philippines was now 20,000. Each year, about 1,000 arrived—mostly into Seattle, Tacoma, and Bremerton. This immigration surge resulted in doubling the Filipino population every 10 years. It also brought problems as old discriminations resurfaced as brown faces became more visible.

The problems of immigrants mandated new programs, such as bilingual education for students taught by bilingual teachers and affirmative action programs for recent arrivals who were well educated and sometimes had advanced degrees—but were relegated to entry-level jobs.

There was a growing problem of poor elderly living in the International District/Chinatown, old-timers who had grown old in America. Young Filipinos and their families experienced the social revolution, which cast away traditional familial values. People seeking peace began to protest and march against the escalation of the Vietnam War.

It was sometimes chaotic yet exciting, as people or groups began seeking solutions for some problems. The Filipino Youth Activities, now an agency, helped put bilingual education in the Seattle Public Schools and developed social programs to deal with employment, drugs, gangs, and family problems. The group Interim fought for better housing in the International District for all Asian elderly. The International Drop In Center (IDIC) provided spiritual and health programs and recreational activities for the elderly.

When martial law was declared in the Philippines in 1972, the politics of the Philippines became entwined with the politics of the Filipino American communities. The anti-Marcos movement collided head-on with the growing momentum of the Filipino American movement started primarily by second-generation Filipinos who were fighting inequality not only for themselves and their families, but also for new immigrants who faced rejections and discrimination based on color and accents. This caused a rift for almost a decade. Yet communities continued to grow.

Paz Rollolazo was the first Mrs. Filipino Community of Seattle in 1969. This was a departure from having young girls as community royalty. After this, young girls were selected to represent the community in the Seafair based on beauty, talent, and personality. Funds raised by contestants through ticket sales were used to underwrite expenses of the community. (Courtesy FANHS.)

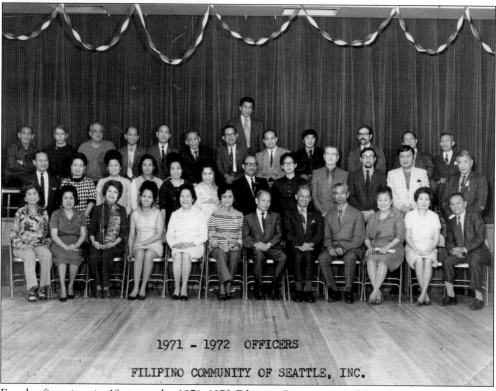

1971 - 1972 OFFICERS
FILIPINO COMMUNITY OF SEATTLE, INC.

For the first time in 18 years, the 1971–1972 Filipino Community of Seattle Council included several second-generation Filipino Americans—all children of pioneer Pinoys. The president that year was Silvestre Tangalan. Unfortunately, this temporary generational blending did not last long. (Courtesy Emma Lawsin.)

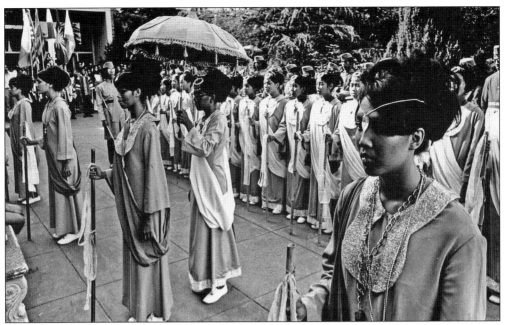

Recognized as the "Birth of the Filipino American Movement," the 1971 Young Filipino Peoples' Far West Convention drew to Seattle University more than 300 from the Far West, Alaska, and Guam under the sponsorship of the Filipino Youth Activities. With the theme "A Quest for Emergence," the FYA had its drill team welcome the delegates. (Courtesy FYA.)

In addition to indoor conference sessions during the first Young Filipino Peoples' Far West Convention, the FYA also provided evening activities, such as dinner dances and this picnic at Seward Park's Pinoy Hill, which drew 500 young people and others who covered the hillside eating *lechon*, hot dogs, and other picnic food. (Courtesy FANHS.)

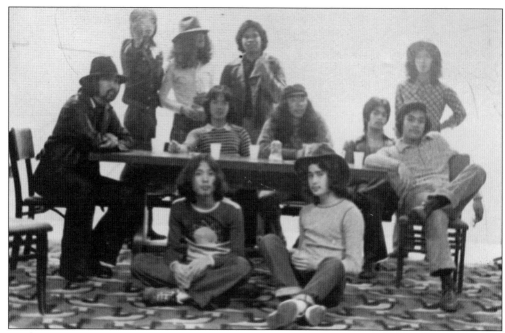

During the 1970s, the rock band Tamaraw gained a following. Initial practice sessions were held in the FYA's old offices in the St. Peter Claver Center building. This group of "hippie-appearing" musicians were, from left to right, (seated on floor) Cesar Pacis and John Sakura; (seated at the table) Steve Aspiras, Alvin Hulgado (Montante), Anthony Cordova, Bobby Verzola, and Damian Cordova; (standing) Terry Takeuchi, Larry Quetola, Alan Bergano, and Ramon Salvador. (Courtesy John Mabalay.)

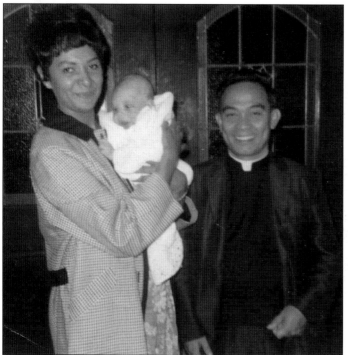

If there's one Catholic priest to remember in Seattle, it's Fr. Manuel Garcia Ocana. When baby Michael Allen was baptized in 1969 at St. Peter's Church, his godparents were Evelyn Roberts and Father Ocana. This priest did not only minister to practicing Catholics but the poor, homeless, vulnerable, and even the Spanish-speaking. (Courtesy Marilyn Allen.)

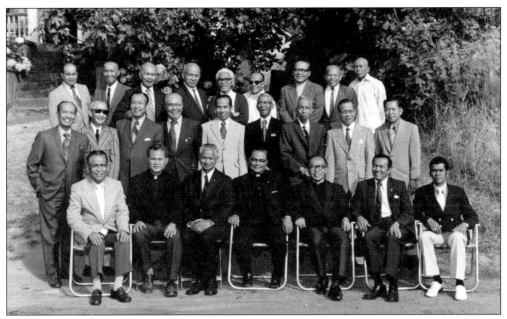

As early as the 1930s, Filipino Catholic men could not be admitted to the Knights of Columbus (KofC) in Seattle. Pinoys were forced to travel 100 miles away to become members of the KofC Council in Chehalis. The Knights organized the KofC Columbian Club and later the Columbianas—the women's auxiliary. One of the priests shown is a young Fr. Jaime Tolang, now the "dean" of Pinoy clergy.

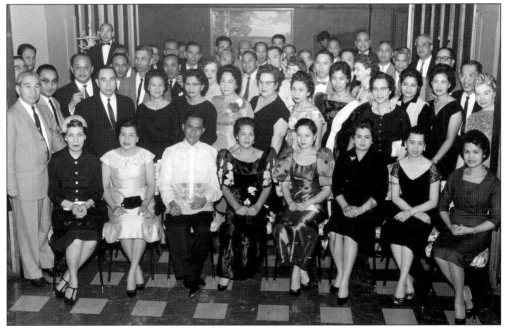

A reception hosted by the consul general was attended by leaders of different communities and organizations in Washington state around 1970. Some attendees were Roy Baldoz of Wapato, John Mina of Puyallup, Vincent Barrios of Bremerton, Dan Sarusal and Salvador del Fierro of Seattle, and Vic Velasco, editor of the *Filipino Forum*. (Courtesy Dolores Sibonga and the *Filipino Forum*.)

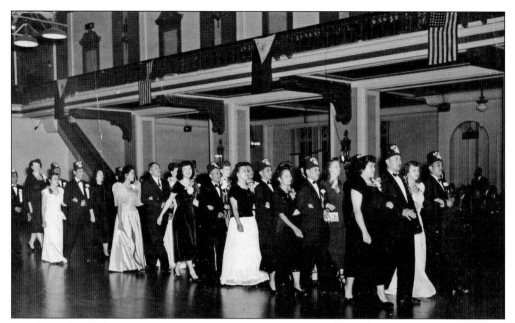

Members of a Filipino fraternal lodge parade with wives and daughters during the lodge ceremonial march before their banquet at the Eagles Auditorium. In Seattle, the Big Three prior to 1965 were the Caballeros de Dimas Alang, Legionarios del Trabajo, and the Gran Oriente Filipino. Also strong in the Northwest were Masonic lodges of the Regional Philippine Grand Lodge in America and the Sovereign Grand Lodge of the Philippine Archipelago. (Courtesy FANHS.)

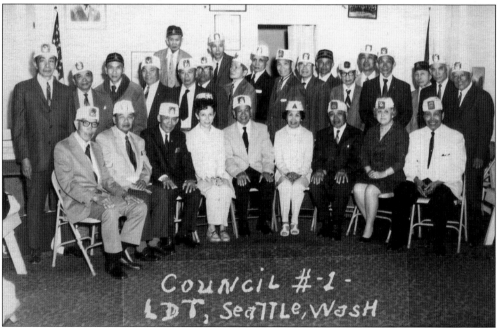

A coalition of Legionarios del Trabajo (LDT) lodges in Puget Sound country was formed into the LDT's Council No. 1. The fraternal organization's name, "Legions of Labor" or "Work," implied the large working force of Filipino American to be united with a fraternal bond in a national lodge for both men and women. (Courtesy FANHS.)

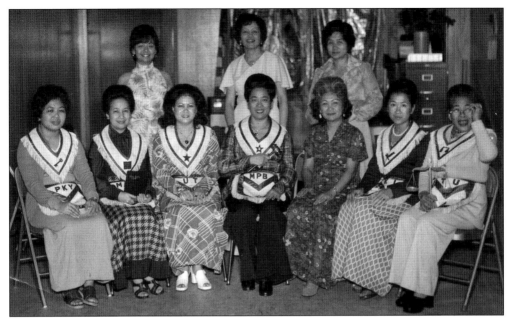

For years, the Caballeros de Dimas Alang (CDA) was the largest and most influential Filipino lodge in Seattle. Officers and members of CDA's Josephine Bracken Auxiliary sit for a portrait in their Seattle headquarters in the 1970s—among them Ruth Mandapat, Puring Dimalanta, Emma Lawsin, and Aurora Quijance. (Courtesy FANHS.)

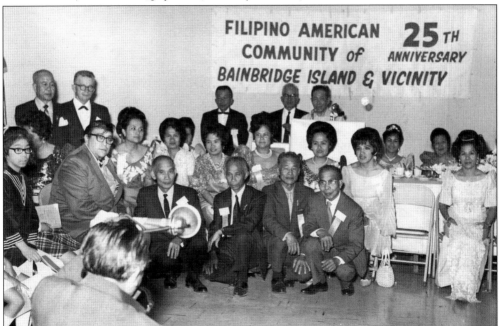

Officers of the Filipino American Community of Bainbridge Island and Vicinity celebrated its 25th anniversary. It was founded by Filipino strawberry farmers—many who married native women from Canada. The emcee is Cornelio Mislang. Joining Bainbridge Filipinos was a contingent from Seattle, including Joan Mendoza Kis and Connie Mejia—past and present Mrs. Filipino Community of Seattle queens. (Courtesy FANHS.)

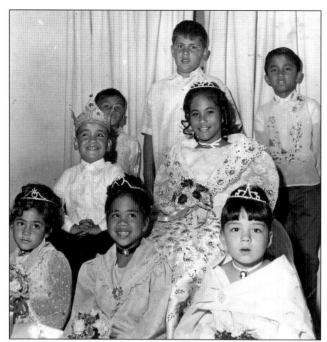

Smiling broadly, Little King Kenneth Calderon and the rest of the Filipino Youth Activities Seafair Royalty enjoy the spotlight during the coronation ceremonies at the chamber of commerce. Beginning in 1957, the FYA was able to underwrite youth programs with monies raised by the Little Royalty. Steps were taken not to exploit the children because of their ages but to provide them with a sense of pride and accomplishment. (Courtesy FYA.)

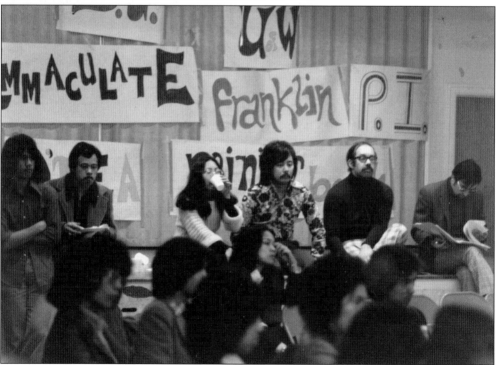

Young activists gather at a *c.* 1971 FYA-sponsored mini-conference to address issues facing the Filipino American community that affect not only youth but also the elderly. Behind them are signs indicating participating schools—University of Washington and O'Dea, Immaculate, Franklin, and Garfield High Schools. Others attending were young educators and others interested in social justice. (Courtesy FYA.)

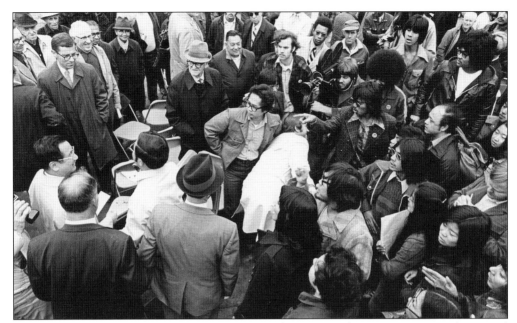

The construction of the King Dome near Chinatown/International District was vigorously opposed by young Asian Americans, who feared elderly residents would be displaced. Protestors at the site around 1975 included Nemesio Domingo (center), Silme Domingo (top right), Frank Irigon, Norris Bacho, Dwayne Baruso, and Roy Flores. (Courtesy Frank Irigon and FANHS.)

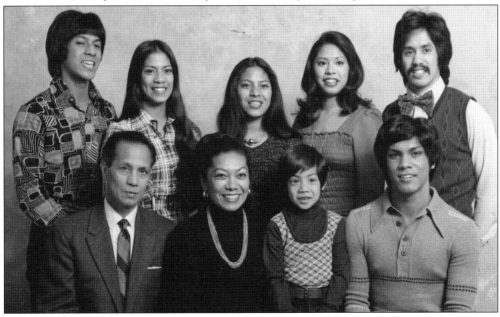

Longtime Seattleite Antonio Pascua "Tony" Mamallo (first row, left), an immigrant from Pangasinan, served in the U.S. Air Corps during World War II and later worked in airplane manufacturing at Boeing Aircraft Company in Seattle. His family included his wife Christine Amado Mamallo (first row, second from left), who was born in California and their seven third-generation children, namely Alan (first row, second from right), Darrell (first row, right) and (second row) from left to right, Gary, Cecilia, Yvonne, Antoinette, and Ernie. (Courtesy FANHS.)

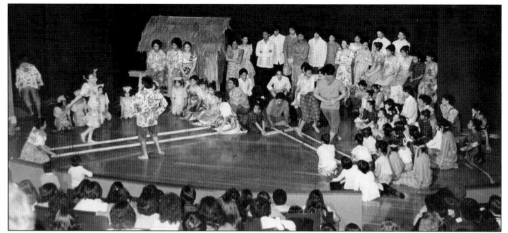

"Palabas," featuring creative, interpretive, ethnic, folk dances and songs, was performed in 1985 through the sponsorship of the Filipino Youth Activities and highlighted the Filipiniana Dance Company, Fiesta Filipina Dance Ensemble, Filipino American Barangay Folk Dancers, Filipino American Barangay Choral, and the FYA Cabataan Folk Dancers, all under the unified direction of Reynaldo Alejandro. (Courtesy FYA.)

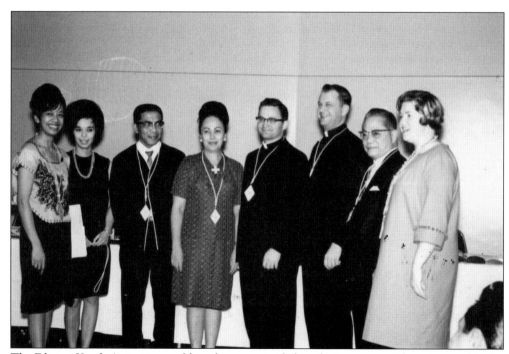

The Filipino Youth Activities would not have survived if not for its patrons. Those invested in the FYA Order of the Tamaraw for outstanding assistance included, from left to right, Harry Subelbia (third from left), Philippine vice-consul Amparo Quevedo, Catholic priests Jay Shanahan and D. Harvey McIntyre, and A. V. ("Rudy") Santos. With them are FYA moderators (volunteers) Nancy Ordona Koslosky (left), Sharon Calderon Ogilvie (second from left), and Terry Lagmay (right). This image is from about 1969. (Courtesy FYA.)

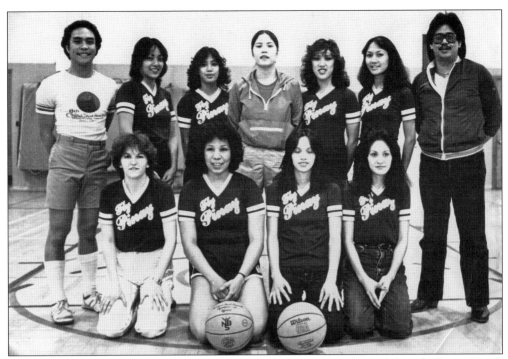

The 1981 champion of the Pac-Asian Girls Basketball League is the undefeated Filipino Youth Activities Fly Pinay, averaging 52 points a game while holding down their opponents to a 28-point average. Family names among the two-year champions include Villarino, Santos, Yumul, Dator, Durham, Hernan, Pickford, Caberto, Bear, Ramos, and Verzosa-Osaki. Damian Cordova (left) was coach, assisted by James Dimalanta (right). (Courtesy FYA.)

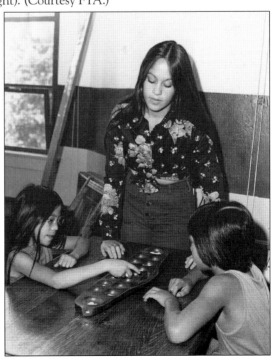

As teenagers got older in the Filipino Youth Activities, they were given more responsibility as growing adults. LeeAnn Subelbia supervises Bibiana Cordova (left) and her brother Dion while they learn to play *sunka* in 1973. Besides counseling the younger children, teenagers helped plan and implement projects. Responsible leadership made it easier for many from the FYA to enter the adult world and do well. (Courtesy FYA.)

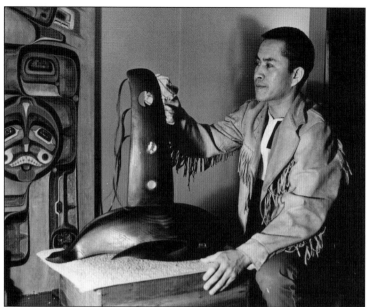

A Native American artist, sculptor, and author of note is Lawney Reyes, a second-generation Filipino American, shown around 1965 while finishing a killer whale Seattle War Dance trophy made of cedar and hair with abalone inlay. Recognized for his carvings and sculptures of Native American motifs, Reyes, winner several art awards, is also an author of books. (Courtesy Lawney Reyes.)

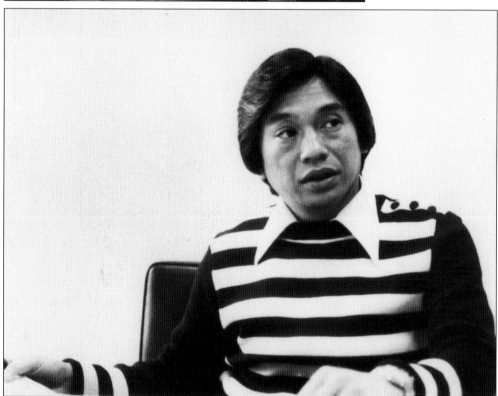

Michael Castillano worked at four institutions of higher education. In the late 1960s through the 1970s, he was the assistant vice president in the University of Washington's Office of Minority Affairs. After a short time with Ivar's Restaurant, he worked at Seattle Central Community College, then South Seattle Community College as dean of students. After a brief retirement, he now works at North Seattle Community College. This is a c. 1970 image. (Courtesy FANHS.)

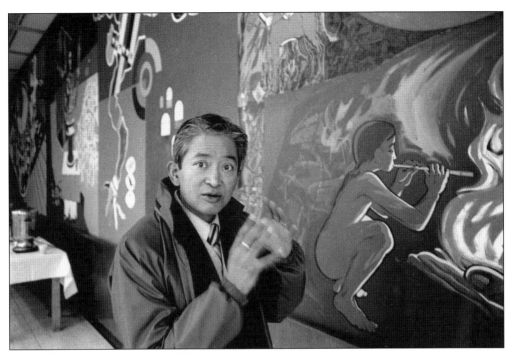

Seattle University art professor Val Laigo painted a large three-paneled mural—Man, *According to Revelation, Man with the Beatific Vision,* and *The Growth of Secular Man*—to reflect the creation of the world. In 1967, the mural was permanently installed in Seattle University's Lemieux Library. Laigo's work has given not only Seattle but higher education a prized legacy in Filipino American art. (Courtesy Chata Laigo.)

Among the long-tenured faculty members of Seattle University is nursing professor Rosario DeGracia, 1999 president of the Filipino Nurses and Health Care Professionals Association. The health organization provides a scholarship to Filipino students in the health care field in nursing, respiratory, occupational or physical therapy, and medical technology. (Courtesy FANHS.)

Luis Taruc, Philippine peasant leader and founder of the Hukbalahap movement, spoke in Seattle under the sponsorship of the Filipino Youth Activities around 1974. After his release from prison, he came to the United States for medical reasons and to retrieve his writing. Taruc was met by anti-Marcos dissidents when he spoke at UW's Ethnic Cultural Center. Community leaders intervened so Taruc could continue his lecture and greet people. (Courtesy FYA.)

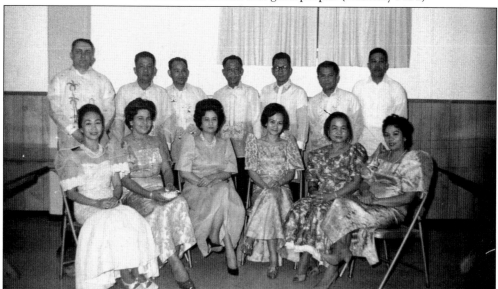

Gussie Jagod (front left) and her husband, Ed (behind her), attend a c. 1969 social event at Fort Lawton in Seattle with other World War II U.S. Army veterans and their wives. They, like other Filipinos, were from the Tacoma-Lakewood area near Fort Lewis. Some were former Philippine Scouts while others served in the U.S. Army 1st and 2nd Infantries, which trained in California. (Courtesy Gussie Jagod.)

Shortly after Christine won the contest to be Little Royalty Queen of the Filipino Youth Activities, her proud parents, Art and Linda Condes, pose with their daughter around 1974. Funds raised by young candidates helped finance the various FYA activities, such as folk dancing, drill team, outings, and cultural and special events, such as Christmas programs, Halloween parties, and teen club dances. (Courtesy FYA.)

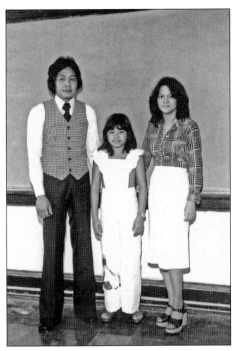

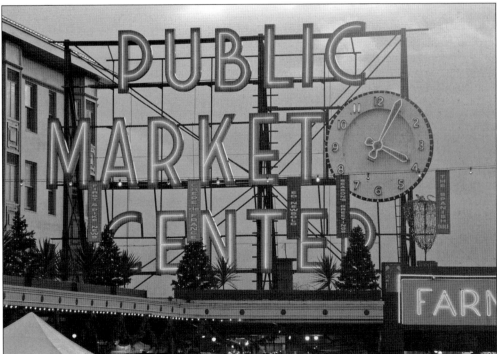

Seattle's popular tourist attraction the Pike Place Market has been a workplace for many Filipinos since the late 1930s. First as tenant farmers, then as owners of farms, they sold their produce and later flowers in outdoor stalls during summer and fall. By the 1960s, some entrepreneurial Filipinos opened year-round small businesses, such as restaurants and small gift and/or jewelry shops on the lower levels. (Courtesy Bibiana Cordova Shannon.)

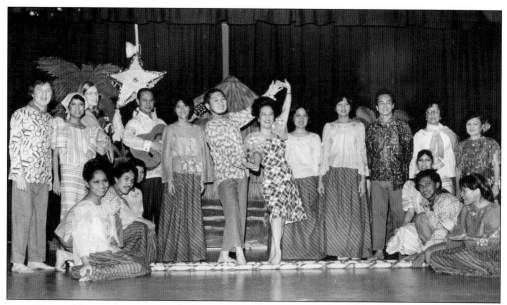

Roger del Rosario and Lydia Palma dance the "Tinikling" flanked by other performers of the Filipinina Troupe: from left to right, (kneeling) Sally Franada, Romy Lamberte, Yoly Salvador Molina, Jimmy Banaag, and Eleanor Calma; (standing) Walter Ciridon, Flori Zamora, Kathy Hagel, Florencio Ponce, Alice Lamberte, Susan Vinluan, Betty Banaag, Rudy Ramirez, Auring del Fierro, and Gaudie Lamberte. (Courtesy Lydia Palma.)

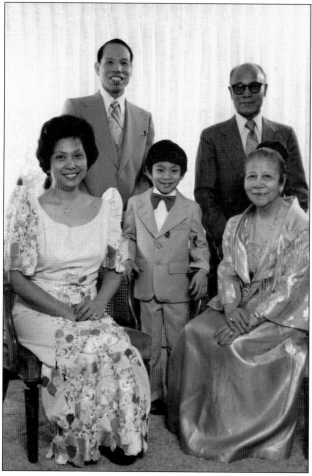

On their 50th wedding anniversary, Carlos and Gregoria Malla pose for a family portrait with their son Lope, daughter-in-law Encarnacion, and grandson Alan. Around 1930, Carlos Malla came to America to work—leaving behind his young wife and baby son. Although he briefly saw them while visiting his hometown as a serviceman at the end of World War II, the family wasn't reunited in America until 1948. (Courtesy Lope Malla.)

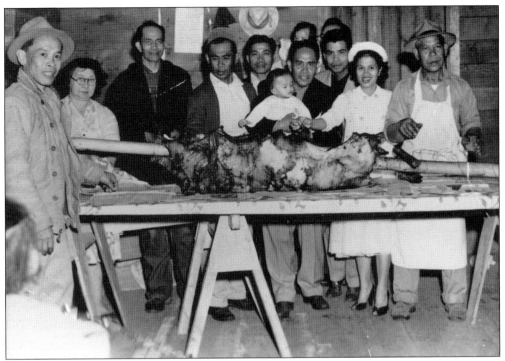

Special celebrations usually meant there was *lechon* or roast pig as the culinary centerpiece. Members of the Filipino Community of Bainbridge Island and Vicinity around 1970 are ready to serve this delicacy—undoubtedly slowly cooked on a spit over an open fire. (Courtesy Joann Oligario.)

Many young Seattle-area Filipinos went to other parts of the country to continue their education and pursue their careers or their dreams. In the late 1980s, young Java Cordova visits his aunt Margarita Cordova now living in New York City. Trips back home and visits by other relatives reinforced family ties. (Courtesy Dorothy Cordova.)

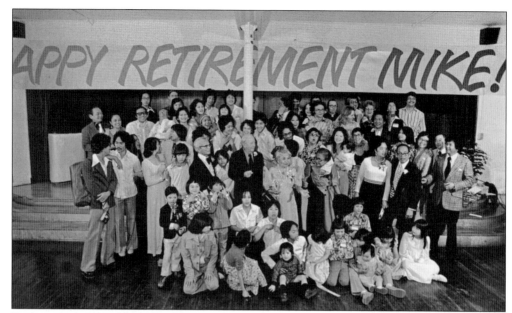

Exuberant children, grandchildren, a brother, and other relatives and friends pose with Mike Castillano Sr. during his c. 1976 retirement party after 30 years as first cook at Ivar's Acres of Clams. As a special gift to his friend and longtime employee, Ivar Haglund (center) gave Mike a check so he and his wife, Bibiana, could visit the Philippines. Bored after several months of retirement, Mike soon returned to Ivar's to personally cook for his boss and to train a new generation of Ivar cooks. (Photograph by Robert Peterson.)

For 18 years, Alicia D. Carlos worked and lived at the Carnation Research Farms. She was the veterinarian in charge of the cattery and the kennels both for Carnation Company and later Nestle. The company was international in scope, and Alicia traveled to Europe and Asia for consultations. She also helped with the large animal work whenever the large animal veterinarian was out of town. This image is dated 1980. (Courtesy Alicia D. Carlos.)

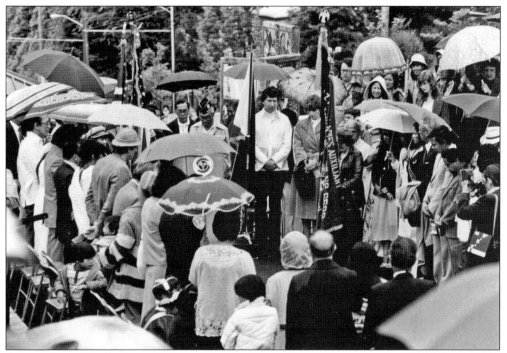

When Mayor Charles Royer dedicated Seattle's Rizal Park, a devoted group—led by Vic Bacho and Trinidad Rojo—had a sense of accomplishment. For years, they pressured city officials to name the bridge near the site after the Philippine national hero Jose Rizal. They next urged Seattle Parks to create, then name, a small park near the bridge for Rizal. This image is from 1982. (Photograph by Dale Tiffany, courtesy FANHS.)

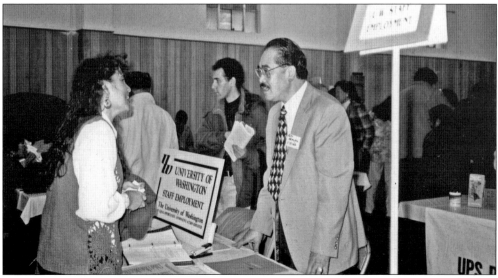

Roy Armas, University of Washington employment specialist, greets job seekers at a job fair cosponsored by the Filipino Youth Activities at the Filipino Community Center. During the 1970s and 1980s, events such as this helped new immigrants learn how to seek and secure employment commensurate with their education. Many came to America with degrees but were often underemployed because of discrimination. (Courtesy FYA.)

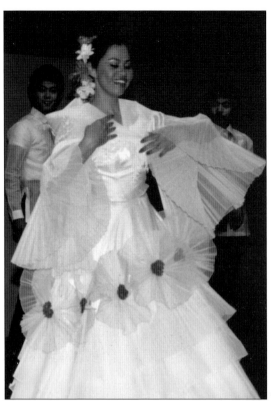

An unidentified dancer in white Maria Clara dress performs at a c. 1988 Pagdiriwang, a festal event held each year at the Seattle Center. (Courtesy Ivan King Photo.)

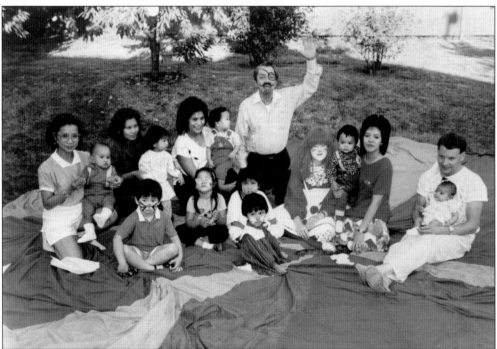

Fun-loving Ben Santos, playing a one-eyed pirate, entertains young children at the picnic birthday party of his grandson Braxton, held by his mother, Mayin (third from left). (Courtesy FYA.)

When still a student at the University of Washington, Marisol Borromeo was the first Filipina to be chosen Seafair Queen—reigning over the two-week summer festival in the Greater Seattle area. As queen, she also represented Seattle in parades in other cities along the West Coast. After graduation, Marisol was a television anchorperson in Hawaii for several years. (Courtesy Dahlia Borromeo.)

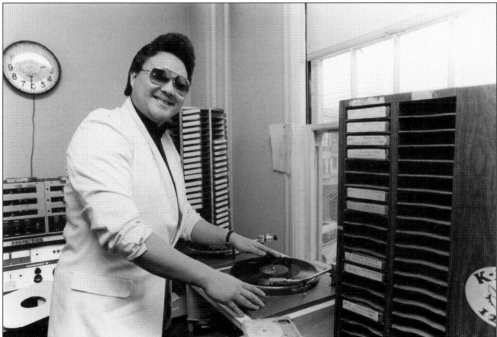

Nes Rodriguez, known by his hip-hop name "Nasty Nes," is a radio disc jockey celebrity whose voice blasted from boom boxes in the 1980s and into the 1990s when Seattle was ushered into a golden era of new records and early artists breaking new ground—until grunge came about. Nes was also a record producer by negotiating magazine contracts and partnerships in the rap culture. This image is from around 1988. (Courtesy FANHS.)

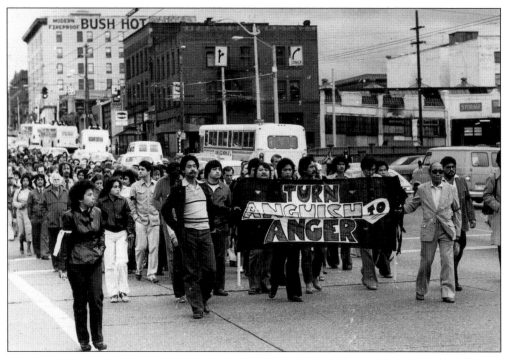

After the tragic murders of Local 37 officers Silme Domingo and Gene Viernes, a sympathetic crowd led by members of the KDP (Katupunan Democratico Politico) march down Jackson Street with the banner "Turn Anguish to Anger" in 1982. Although there was speculation the murders had to do with gambling in the canneries, many others felt it was because of the victims' "anti-martial law" activities. (Courtesy the *International Examiner*.)

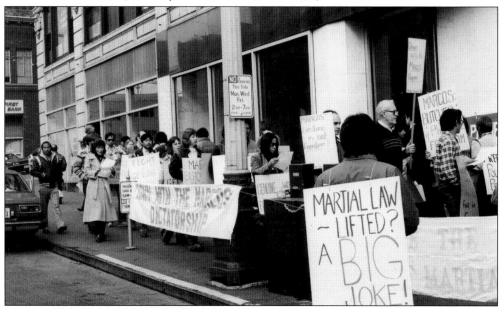

Just before the peaceful People Power Revolution in the Philippines, a crowd protesting martial law carries placards outside the Philippine Consulate offices in Seattle. (Courtesy the *International Examiner*.)

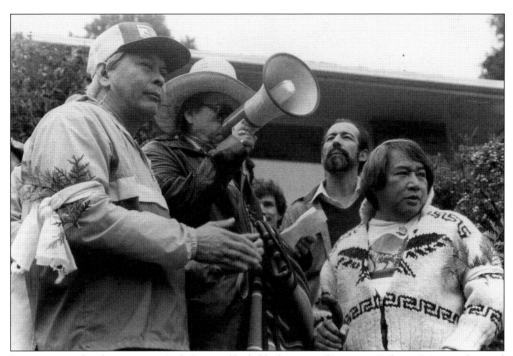

Longtime civil rights activists Bob Santos (far left), director of Interim; Roberto Maestas (second from right), director of El Centro dela Raza; and Bernie Whitebear (right), director of Indians of All Tribes, protest outside the Russian consul's home. Both Bob and Bernie are mestizos—or Indipinos. (Courtesy the *International Examiner.*)

Myron Apelado was born in Chicago, the only child of an African American mother and a Filipino father. A talented musician, he chose to become an educator. While he was vice president for the Minority Affairs at the University of Washington from 1990 to 2000, support services for recreational underrepresented minority students increased. (Courtesy Myron Apelado.)

The Filipino Youth Activities emerged from a leisure-time program for youth to one with an administrative office that daily spent time on the social needs not only of youth but its families. John Ragudos was its longtime executive director, assisted by program coordinator Charles Farrell. The FYA office for years assisted many of the needy and vulnerable "from the womb to the tomb." (Courtesy FYA.)

Laarni Fernando and Betty Sumaoang Ragudos, both moderators teaching folk dance, give out Christmas gifts to the young ones in the Filipino Youth Activities as well as to all other children. Like with other FYA programs, many children recipients are of other races, Filipino either by blood, adoption, foster care, or even by choice. (Courtesy FYA.)

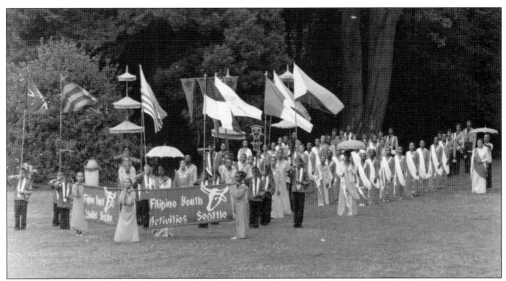

Ninety-nine people make up the Filipino Youth Activities Khordobah, comprising the Princesa Drill Team, Cumbanchero Percussioneers, and Mandayan Marchers—ready for their Washington, D.C., tour in 1985. The nation's only Filipino American drill team has performed throughout the Far West, Hawaii, Alaska, and Western Canada and won hundreds of sweepstakes and first-place awards against military, school, ethnic, musical bands and other competitive marching units. FYA youths, from 7 to 19, are predominantly American-born. (Courtesy FYA.)

The third location of the Manila Café was smaller and away from its regular customers but somehow had more business. Sarah and Fernando Martinez, around 1990, now after 40 years, seem content with the living this restaurant had provided them and members of their family. In a few years, they would relinquish ownership to their granddaughter. (Courtesy Sandra Martinez.)

Vince Lawsin (back) talks to his family. From left to right, they are grandson Marvin Rosete, son Vincent Jr., daughter Emily, and a friend during an FYA Drill Team Merienda around 1986. These annual events took place after the drill team's parade season. Lawsin is a past president of the Filipino Community of Seattle. Emily is now a trustee of FANHS. (Courtesy FANHS.)

Attending the same FYA event were Frank and Felicita Irigon, their son Pax, and daughter Teresa. Felicita was also on the drill team as a teenager. She became a social worker, as did Frank, a community activist since his college days. (Courtesy FANHS.)

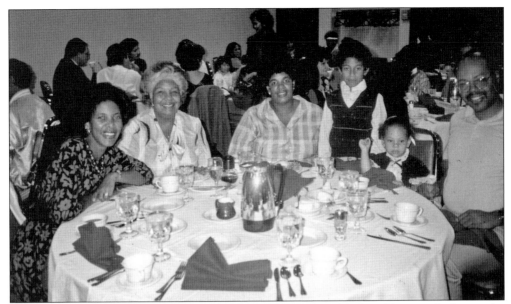

Dolores Bradley (second from left), granddaughter of Frank and Rufina Clemente Jenkins—the Filipino community's first family—enjoys the FYA Merienda with her daughters, Carol (left) and Linda Thompson (center), and friend, Stan Harris (far left), seated with small daughter Natasha and nephew Carl Frutos. Dolores is the daughter of Francesca, the oldest Jenkins child and the only girl. (Courtesy FANHS.)

A family portrait shows Marilyn Laigo Senour and her husband, Dan, with their three daughters, from left to right, Serena, Danielle, and Sabrina. Marilyn was the oldest child of Ben Laigo Sr., who came from Bauang, La Union, in the late 1920s. Her mother was mestiza—daughter of a Filipino father and Alaska Native mother. (Courtesy Marilyn Senour.)

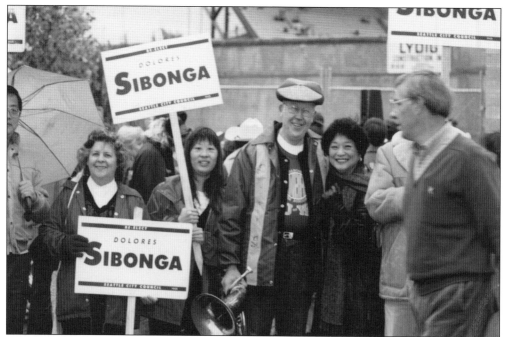

Dolores Sibonga, the first Filipina elected to the city council or its equivalent in any major American city, campaigns outside the old Domed Stadium. She was also the first Filipino to graduate from the UW Law School. This high-achieving civil rights activist was elected to four consecutive terms as a Seattle City Council member. Dolores retired in early 1990s. (Courtesy Dolores Sibonga.)

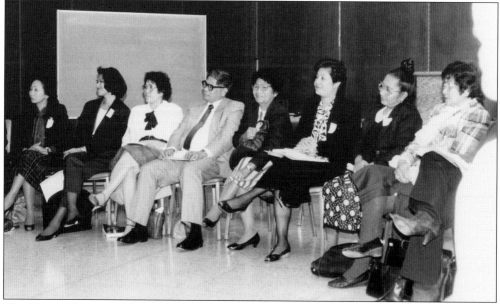

The Filipino American National Historical Society became a truly national organization in 1987. Its first National Conference in Seattle drew 90 participants from as far away as Los Angeles, Chicago, and Anchorage. Gathered at Seattle University were those who by their smiles gave FANHS the initial community support on its nationwide mission. (Courtesy FANHS.)

Five

CHANGING COMMUNITIES

There have always been Filipino communities in Puget Sound—Seattle, Tacoma, Bremerton, Bainbridge, and Auburn, to name a few. Pioneer Filipinos moved freely between them because they had friends there. Today new communities have emerged in areas that once had few Filipinos and were small towns, farmlands, suburbs, or wooded areas, such as Filipino American Community of South Puget Sound in Olympia, Filipino-American Association of North Puget Sound, Filipino-American Community of Lynnwood, Filipino-American Association of Shoreline, Filipino-American Association of Greater Federal Way, Filipino-American Association of Oak Harbor, and Filipino-American Community of Renton.

However, with the recent addition to its clubhouse, the Filipino Community of Seattle still remains the premier community—especially since many council members and officers come from surrounding cities and towns.

Once close-knit and geographically contained, Filipino Americans are now spread throughout Puget Sound. Most do not know others outside of their immediate circles. Filipinos once joined lodges or organizations based on regional kinship or employment (usually blue collar), which provided much needed support during more trying times. Now many are only part of their large clan or with groups affiliated with a parish or spiritual mission or special interest organizations—Filipino Chamber of Commerce, Filipino American Political Action Group of Washington (FAPAGOW), or Filipino American Student Association (FASA) affiliations.

The Filipino population has grown tremendously because of immigration. Sixty percent of Filipinos in Washington state are immigrants who have come since 1965. Many arrived as three generations: parents, children, and grandchildren. Although Filipinos are the second largest Asian American group in the United States, they are the largest in Washington state—if we count all our third- and fourth-generation mestizos.

In some ways, we have become more Filipinized. Celebrating Philippine town fiestas has become an annual event. The Philippine Christmas tradition—*Simbang Gabi*—is celebrated throughout the Catholic Archdiocese of Seattle. Philippine movies and entertainers have a following.

There is a disconnect with early Filipino American experiences. Many recent immigrants and young American-born Pinoys think benefits they enjoy today were always there. Once relegated to entry-level or menial jobs, today many Filipino Americans are professionals. Some have positions the earliest immigrants never dreamed possible.

Yet there is still much to do.

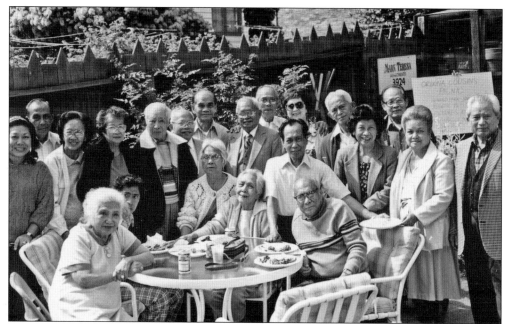

These old-timers at a 1990 garden party were among the last of the large number of Filipino immigrants from La Union who came to America during the 1920s and 1930s. The earliest pioneers—all with white hair—are from left to right, (seated) Bibiana Castillano, Ida Floresca, Carmen Pimental, Victor Laigo; (standing) Ignacio Pimentel, Silvestre Tangalan, Mariano Laigo, Fel Ordonia, Mike Castillano, and Boni Hipol. (Courtesy Barbara Laigo Martin.)

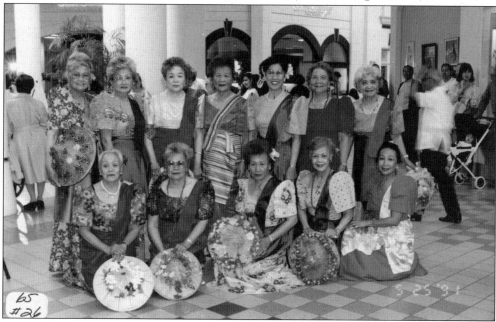

The "Golden Girls" of Tacoma, Washington, sit together before their performance in 1991. Gussie Jagod (kneeling, far right) began training this group of friends to dance for community events in the 1970s. All were wives of Filipino veterans of the 1st and 2nd Filipino Infantries of the U.S. Army or of Bataan-Corregidor survivors.

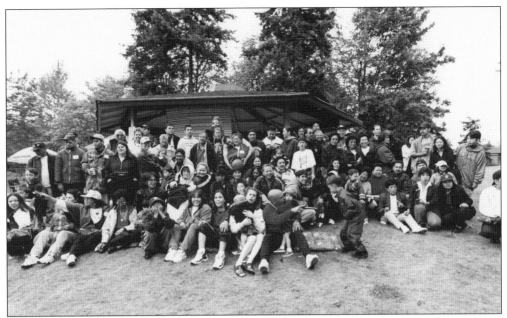

A small gathering of one of Seattle's oldest and largest groups of Filipino American kinfolk is the Laigo family, whose Pinoy generation now extends from first-generation Philippine immigrants to the American-born fifth generation. The family's much diversified composition reflects modern America with its multiracial ethnicities, bound in an ancestral Philippine heritage, with the first coming of three Laigo cousins in 1919 to Seattle. (Courtesy Lisa Laigo Santos.)

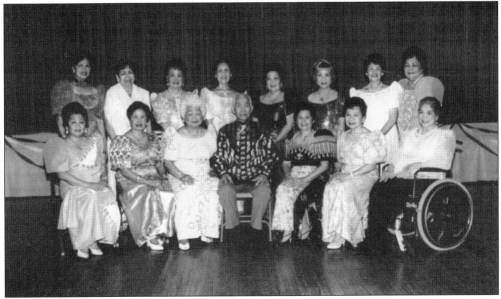

The Philippine War Brides Association, founded by Mariano B. Angeles (first row, center) in 1949, has given an important contribution to the development of the Filipino American community. Its members, wives of World War II servicemen, promoted togetherness, mutual understanding, and cooperation in the general community at large while volunteering for cultural activities and social programs. Significantly, their children have grown to be among the next Pinoy generation of potential leaders. (Courtesy Betty Sumaoang Ragudos.)

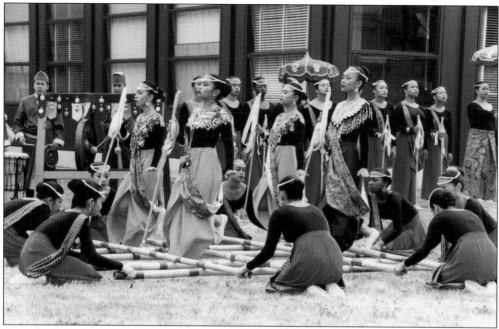

Team leaders of the *c.* 1990 FYA Princesa Drill Team—from left to right, Mona Bumbao, Lara Mae Divina, Jessica Molina, and Christy Aquino—step smartly through bamboo poles clapped in a syncopated beat while Cumbancheros in the background play the gongs. (Courtesy FYA.)

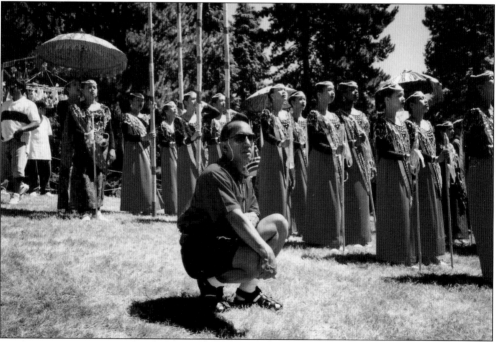

FYA Datu Ron Consego waits with his team before their performance at Pista sa Nayon in Seward Park. Since 1989, Ron and his wife, Lynnette—both former drill team leaders—assumed full responsibility of the team, which has remained the most popular and visible of all Filipino Youth Activities programs. (Courtesy FYA.)

During the 40th anniversary of the drill team in 1997, the *Pajwelas*—the first members—watch while Fred Cordova, drill team founder and original Datu, speaks. Among all the different FYA programs, the drill team was unique and built the strongest *esprit de corps* among their participants. Young people who joined as children have remained friends for many decades. (Courtesy FYA.)

Ruth Mocorro (right), FYA staff secretary, and board member Linda Timmens prepare decorations for their booth at a mall. In order to raise funds and to share information, the Filipino Youth Activities often participated in annual cultural and ethnic festivals in the area. (Courtesy FYA.)

Bob Santos greets old friends Ed and Mae Laigo during a reception at his new office when he was named the secretary's representative of the U.S. Department of Housing and Urban Development (HUD) for the Northwest/Alaska Area during the Clinton administration. A longtime civil rights activist, as director of Interim, Bob brought many housing and social improvements in Seattle's International District. (Courtesy Bob Santos.)

Historians featured in the FANHS video *Filipino Americans: Discovering their Past for the Future* are seated from left to right: Alex Fabros, Helen Nagtalon Miller, Don Guimary, Marina Espina, and Fred Cordova. Standing (from left to right) are project staff and friends Dorothy Laigo Cordova, Nori Catabay, Anna Ebat, Cynthia Mejia, Jackie Jamero Berganio, and Kevin Ebat. The video received two national awards. (Courtesy FANHS.)

Held ever year during Seafair, Seattle's summer maritime extravaganza is the Pista Sa Nayon, drawing a multitude of Filipino Americans to Seward Park for an outdoor amphitheater show along with various food and cultural booths. Performing an exhibition is the Filipino Youth Activities Drill Team. (Courtesy Ron Buenaventura.)

Enjoying the festival is a contingent from the Filipino American National Historical Society, including visiting members of its board of trustees with cohorts from as far away as Philadelphia, Albuquerque, Anchorage, Portland, Los Angeles, Vallejo, San Jose, and even Everett. (Courtesy Ron Buenaventura.)

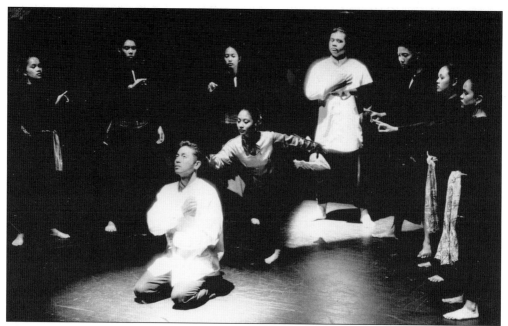

The central character in Timoteo Cordova's play *Heart of the Son* is the Philippine Revolution leader Emilio Aguinaldo, played by Tony Colinares. In this scene, while circled by dancer Ann Marie Dofredo, he is received into the Katipunan, a secret society founded by Andres Bonifacio (back, in white shirt). This image was taken in 1995. (Courtesy FANHS.)

Standing before one of the unique and beautiful Philippine clothing artifacts is artist Jeannette Castillano Tiffany (left), exhibit curator for the "Mabuhay, Pilipinas!" cultural arts celebration at the 1996 Northwest Folk Life Festival. She is also a founding board member of the Filipino American National Historical Society. (Courtesy FANHS.)

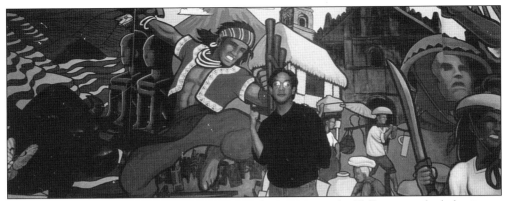

Timoteo Cordova stands in front of the Pinoy Teach History Mural—*Phillenium*—which dominates the Filipino Community Center's northern exterior. It was a 1998 gift to the Filipino community from Pinoy Teach and other Filipino American artists, students, historians, and community activists. Cordova was project manager and Rafael Calonza Jr. lead artist for the massive mural, which depicts 2,000 years of the Philippine and Filipino American experience. (Courtesy FANHS.)

Pinoy Teach, a multicultural curriculum that teaches Philippine and Filipino American histories and experiences, was conceived by Timoteo Cordova, who then developed it further with Patricia Espiritu Halagao. This unique and dynamic program trained college students to share and teach these histories with students in several area middle schools. While most teachers were Filipino, most students were not. (Courtesy FANHS.)

Former Philippine vice president Salvador P. Laurel, Philippine National Centennial Commission general chair, speaks at the 1997 Pagdiriwang, commemorating in Seattle Center the 99th anniversary of the Philippine Independence from Spain. With him are, from left to right, Flori Montante, Larry Alcantara, Ellen Abellera, Salud Sampaga, and Dr. Alex Paves. Flori Montante is president of the Filipino Cultural Heritage Society of Washington, which annually produces Pagdiriwang. (Courtesy Marfelita Felix.)

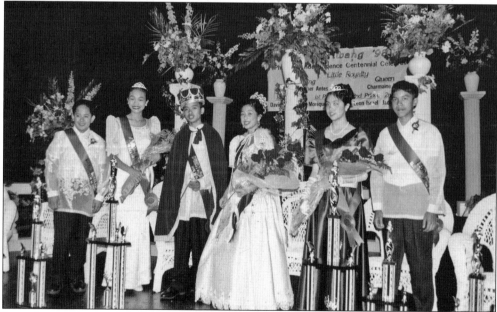

Every June at the Seattle Center, the festival Pagdiriwang annually commemorates the Philippine Independence from Spain. Making the celebration possible financially is a Little Royalty Court. The 1968 royalties include (center) Queen Charmaine Unite Felix and King Christopher Antis and, from left to right, David Dimalanta, Monique Borromeo, Jade Crisostomo, and Rafael Santo Domingo. (Courtesy Marfelita Felix.)

The Fil-Am Society Choir in Magnolia was founded in 1979 at Our Lady of Fatima Parish by composer Anselmo Pelayre (right) and his daughter, Carmen (left), as choir director. The choir is a mainstay for Seattle festivals and Filipino religious events in many other churches. First organized for Fatima parishioners with Pelayre children and grandchildren taking part, the choir now has an open membership. (Courtesy Carmen Pelayre.)

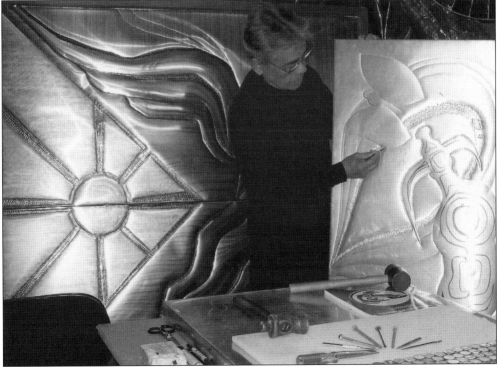

Weng Gavino is a multi-faceted artist—muralist, singer-composer, and technology consultant. While still in the Philippines, he learned intaglio mural art, which is the fanciful experimentation of massive and moving textures of bronze, brass, copper, and gold on ultra-thin aluminum sheets—resulting in impressionistic "paintings" on tooled metal. His most notable mural hangs on the wall of the Filipino Community ballroom. (Courtesy Weng Gavino.)

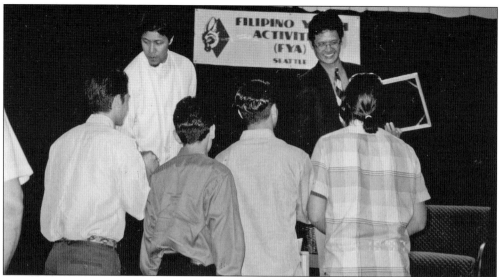

The Pulitzer Prizes are annual awards for achievement in American journalism, letters, drama, and music. In 1997, two Filipino American journalists from the *Seattle Times* were recipients: Alex Tizon (standing, left) for investigative reporting and aerospace reporter Byron Acohido (standing, right) for beat reporting. Tizon won for a series that exposed federal sloppiness in managing Native American housing and Acohido mainly for a puzzling Boeing problem on 737 jet rudder mechanisms. (Courtesy FANHS.)

Roger Serra has a long history in law enforcement, as well as in security and emergency management. After years with the University of Washington Police Department, where he served as chief of police, he became executive director for the Snohomish County Department of Emergency Management. He currently is director of security and emergency management for the Seattle City Light. (Courtesy Roger Serra.)

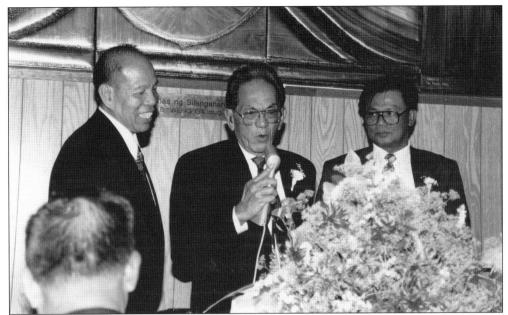

Grand Master Robert T. Taporco greeted members of his Gran Oriente Filipino as Deputy Grand Master Lope Malla (left) and Rino Rabang (right) look on. The Gran Oriente has three lodges and one chapter in the Pacific Northwest: Bataan Lodge, Taal Lodge, Zamora Lodge, and the East-West Ladies Chapter. Belonging to the Ancient Free and Accepted Masons, the Gran Oriente is one of three leading Filipino American fraternities. (Courtesy Lope Malla.)

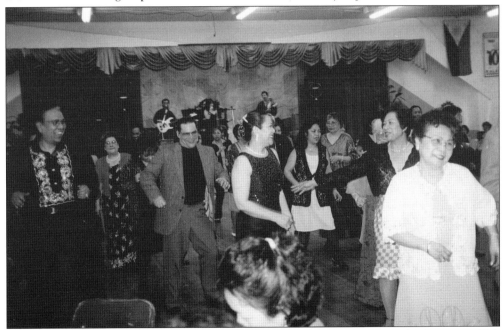

Dancing the electric slide during a c. 1999 dance held by the Bataan Corregidor Survivors Club at the Filipino Community hall are members and friends of the group, including from left to right, (first row) Bert Caoili, FCC president; John Ragudos, FYA executive director; Alma Kern; and Fanny Sumaoang (with her arm extended). (Courtesy Fanny Sumaoang.)

In July 2008, the Baguio City High School International Alumni Association (BCHSIAA), Pacific Northwest Chapter, hosted the sixth triennial BCHSIAA Reunion in Silverdale, Washington. This photograph includes, from left to right, (seated) Northwest members Adelina Pajel-Miller and Yolada Morita. Others include Bob Meria, Alice Carlos, Imelda and Ed Soriano, Tina Jankford, Fil and Edna Erfe, Rudy and Tina Nartea, Leo and Aida Monis, Mary Ann and Quintin Mugas, and Grace Avila Furigay. (Courtesy Yolanda Morita.)

The Filipino American Civic Employees of Seattle (FACES) provides members with valuable training through its annual conferences. Each year, FACES also invites exemplary Filipino Americans who share their work and personal experiences. At their 2007 conference, from left to right, Brenda Sevilla, FACES president, greets luncheon speaker retired Brig. Gen. Oscar B. Hilman and J. D. Hokoyama, keynote speaker. Also with them are Eddie Ferrrer and Adrienne Chu of FACES and Thelma Sevilla, emcee. (Courtesy Brenda Sevilla.)

During a program in Olympia, capital of Washington state, members of Young Once pose with Gov. Christine Gregoire. Under the director of Dolly Castillo, the senior citizen chorale and dancers from the International Drop In Center (IDIC) perform throughout Puget Sound. IDIC provides social services and recreational activities for Filipino elderly. (Courtesy Sluggo Rigor.)

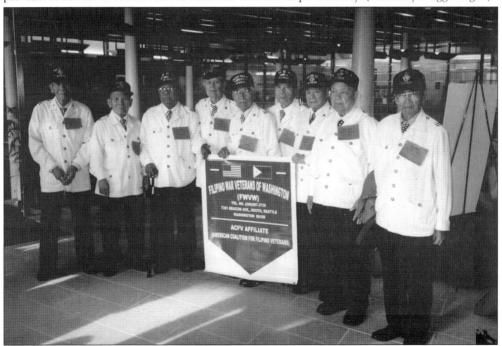

These veterans are part of a larger group of Filipinos who fought for the United States in the Philippines as members of the Philippine Scouts or guerillas during World War II. Denied benefits promised after the war ended, many have come to America seeking equity and the release of benefits from Congress. IDIC has provided assistance to these veterans. (Courtesy Sluggo Rigor.)

Ernie Rios (left) has the entrepreneurial spirit. In the past 25 or so years, he has opened a beauty shop and five restaurants. The most recent is named Inay's as a tribute to his mother, who ran the first small venture and is the source of many delicious family recipes. Ernie stands with friends before one of the many Philippine fabrics decorating his restaurant. (Courtesy Ernie Rios.)

Whidbey Island, one of the largest islands in the United States, is also the home of a naval air base. There is a large Filipino community—mostly active and retired U.S. Navy personnel and their families. At this gathering, two founding members of that community, Betty Letrondo (fifth from right) and Berta Letrondo (third from right) enjoy the company of family and friends. Fr. Denis Sevilla is sitting between them. (Courtesy Brenda Sevilla.)

At the 2004 Filipino American Civic Employees of Seattle (FACES) conference, the keynote speaker, Maj. Gen. Antonio Taguba, sits with David Della, City of Seattle council member, and Marya Castillano, director of conservation for Seattle City Light. The recipient of many military awards, General Taguba is best known for investigating detainee abuse at the Abu Ghraib Prison at the beginning of the War in Iraq. (Courtesy Marya Castillano.)

Eric Scharer, Ivar's Restaurant manager, greets Nate McMillan, former coach of the Seattle Sonics basketball team and present coach of the Portland Trailblazers. Eric continues the tradition of his grandfather, Mike Castillano, as an Ivar's employee. (Courtesy Marya Castillano.)

Feling Bergaio (center left) and Willy Bucsit (right) playfully pose during the 2008 Bainbridge Island Strawberry Festival sponsored each year by the local Filipino Community. Feling and Willy are two pioneer Filipinos who began farming on the island during the 1940s.

At the 2003 Pilar Family Reunion held in Seattle, the Fred Cordova segment of that large extended California family poses for a picture under large trees at Woodland Park. Please note the different racial mix of the Cordova clan—Filipino, African American, Mexican, and white. (Courtesy Fred Cordova.)

During the Great Depression, many early Filipino immigrants survived because of extended families, which sometimes included non-relative friends. After the funeral of Ed Pimentel, his modern Filipino extended family—all American-born—hoists a glass of his favorite beverage to honor him. Headed by new matriarch Loretta Pimentel Orpilla, this clan includes both Pimentel and Laigo relatives. (Courtesy Loretta Pimentel.)

Fred Verzosa arrived in America on December 24, 1985. His wife, Thelma, and their children did not come until 1994. Their story is typical of many recent educated, hardworking Filipino immigrants—who have in many ways attained their American dream. Thelma is a nurse, and for many years, Fred was the accountant for Seattle Aquarium. As a result of his outstanding work, he recently was named strategic advisor for the Seattle Parks Department. (Courtesy Fred Verzosa.)

The Bachos and Berganos who grew up in Seattle's Central Area or District attended the 80th birthday of Remy Bacho. Some have moved away, but they have maintained their friendships. Peter Bacho (top left), an award-winning author, is a professor at the UW Tacoma Campus. Allan Bergano (center), a dentist in Virginia Beach, Virginia, founded the FANHS chapter in that city. Others who remained in Seattle are Norris Bacho (right), his sister Irma (seated left), and Bergano sisters, left to right, Barbara and Cheryl. (Courtesy Dr. Allan Bergano.)

Attending newly ordained deacon Fred Cordova's reception are relatives and friends who have contributed to the cultural growth of Filipinos in Puget Sound. His niece, Gussie Jagod (left), dance director of PAYO, is the cultural leader in Tacoma. Cousin Flori Montante (second from left), director of Pagdiriwang, the annual festal event at the Seattle Center, also directs a chorale. Friends Violeta and Vance Noriega (seated) share Philippine culture by publishing Vi's books. (Courtesy Concordia Borja-Mamaril.)

Globe-trotting educator Gloria Adams (center) and her four children are pictured in a family portrait. A retired public school counselor, Gloria founded the Filipino American Educators of Washington (FAEW), an organization now headed by daughter Loren Divina (second from right). Gloria and her family are also involved in many civic ventures—truly giving back to the community. (Courtesy Myrna Victoriano.)

One of Seattle's better known couples is Edna and Lucho Alvear Singh. Lucho manages an independently owned insurance and financial planning organization. He is also known as a golf practitioner, producer, and entrepreneur in the Philippines. Edna, having come to Seattle, was a secretary in the Philippine Consulate General office. They are the parents of two grown children, college-bred, and professionals in their respective careers. (Courtesy Lucho Singh.)

PRIMO KIM
VILLARRUZ
in concert
BENAROYA HALL

to Benefit Filipino Youth Scholarships through
FANHS *(Filipino-American National Historical Society), a non-profit organization*

Former Californian Primo Kim has been a fixture in the Seattle entertainment scene for more than 30 years and has performed in most major venues in the lower Puget Sound. At times, this talented pianist and singer produces benefits for nonprofits. (Courtesy Primo Kim.)

Angelo Pizarro is a quiet person who plays guitar full of verve and conviction. He is promoted as a writer and performer of "improvisational acoustic and electric guitar music, mixing the traditional sounds of his Filipino heritage with the electrified funk and rock of his youth." Since he was the main instrumentalist in Tim Cordova's play *Heart of the Son*, Angelo has focused on the acoustic sound of the Spanish guitar. (Courtesy Annette Pizarro.)

Vic Noriega, an original jazz pianist, has, as stated in promotional material, "impressed audiences worldwide with his dynamic command of the piano and his inventive and compelling improvisations." He has performed in New York City, Canada, and Shanghai's growing jazz scene. Noriega received the prestigious Golden Ear Awards by Earshot Jazz as Emerging Artist of the Year (2005), Northwest Instrumentalist of the year (2006), and Northwest Recording of the Year (2006) for his album *ALAY*. (Courtesy Vi Noriega.)

George Quibuyen, also known as "Geologic," is the MC partner of Blue Scholars, a popular and fast-rising hip-hop duo based in Seattle. His DJ partner is "Sabzi" (Saba Mohajerjasbi). Geologic, the vocalist for Blue Scholars, lived along the West Coast and Hawaii as a child until his immigrant family settled in Bremerton. He met Sabzi when both were students at the University of Washington. (Courtesy Blue Scholars.)

The liberal "young Turks" of the 1970s—now mellowed and grayer—gathered at the Tiffany home to welcome former Seattleite Peter Jamero, in town in 2006 for a book-signing party for his book *Growing Up Brown*. Old friends include, from left to right, Anthony Ogilvie, Bob Santos, Pete Jamero, Dale Tiffany (in back of Pete), Fred Cordova, Sonny Tangalin, Larry Flores, and Roy Flores. (Photograph by Dale Tiffany.)

Also present at the reception for Pete and Terri Jamero were female friends of the couple—all as accomplished as their husbands. From left to right are Betty Sumaoang Ragudos, Bernie Agor-Matsuno, Evangeline Domingo Keefe, Elisa Flor (seated), Vicki Lee, Dorothy Laigo Cordova, Sharon Tomiko Santos, Terri Jamero, Angie Quintero Flores, Jeannette Castillano Tiffany, and Marya Castillano Bergstrom. (Photograph by Dale Tiffany.)

Karen Monares Bryant is the great-granddaughter of Annie Cantil, a Tsimpshean from Alaska, and Diego Cantil, an immigrant from Cebu. A high school basketball star, she later played for Seattle University and the University of Washington. She was on the staff of the Seattle Reign and the Seattle Storm. When the Oklahoma owners of the Seattle Sonics sold the women's team, the new owners named Karen CEO of the Seattle Storm. (Courtesy Seattle Storm.)

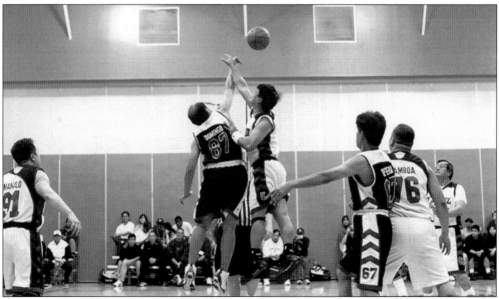

Jun Estrada (center left) of Windermere Realty/Dofredo and Tony Domingo (center right) of Lucho Singh Insurance go up for the jump ball to start the 2008 championship game of the Life After Forty Basketball League's fall season. The game was won by Windermere Realty, 52-48. (Courtesy Joysha Fajardo.)

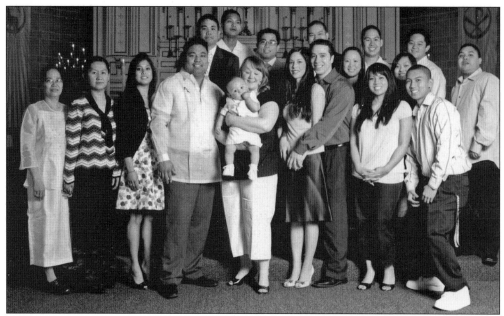

When Anthony James, son of Antonio and Carrie Casila (center), was baptized at Immaculate Conception Church, his parents followed the time-honored Filipino custom of many godparents. *Ninongs* (godfathers) and *Ninangs* (godmothers) include Luz Campbell, Melanie del Rosario, April and Jeremy DeJesus, Gabriel Era, Fred Arcala, Mario Santos, Marissa Lo, Chris Valdez, Astra Era, Joshua Alcantara, Manny Salgado, Mary and Geoff Urbina, and Denise and Daniel Tunay. (Photograph by Jonathon Alcantara.)

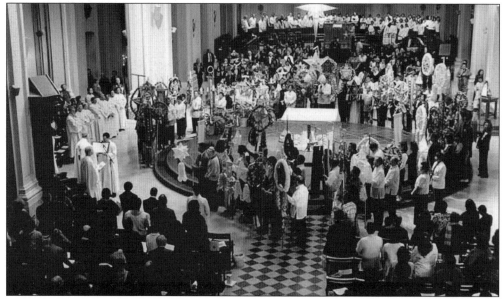

Each year, the first *Simbang Gabi* mass of the Catholic Archdiocese of Seattle is celebrated at St. James Cathedral. Most parishes participate in this annual event, and representatives carry handmade or purchased *parols* (Christmas stars) in a spectacular procession from the back of the church to the altar. In the Philippines, *Simbang Gabi* was a special Christmas mass. Post-1965 Filipino immigrants brought this custom to America. (Courtesy Catholic Archdiocese of Seattle.)

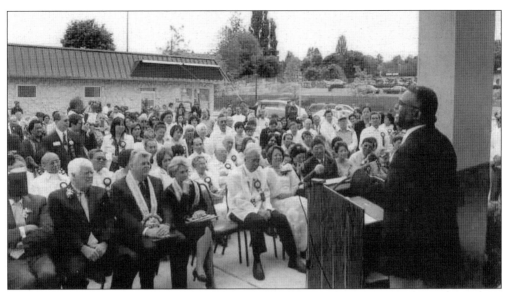

At the dedication of the new addition to the Filipino Community Center listening to King County executive Ron Sims are, from left to right, (first row seated) Rep. Jim McDermott, Mayor Greg Nichols, and Gov. Christine Gregoire. The remodeled center now has offices for staff; new meeting, conference, and multi-purpose activity spaces; a large lobby; library; and much-needed restrooms. The new Spanish-style south entryway welcomes visitors. (Courtesy the Filipino Community of Seattle.)

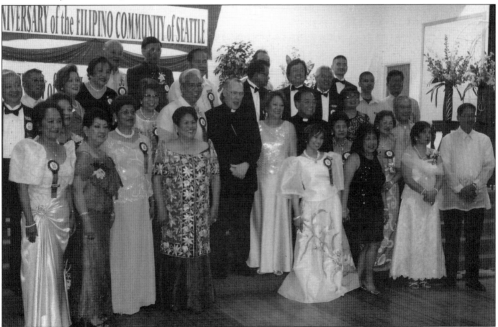

The Filipino Community of Seattle and Vicinity ended dedication day with a formal dinner and dance. After blessing the new addition to the Filipino Community Center, archbishop Alexander Brunett (center) poses with officers of the community council. FCC president Bert Caoili stands left of the archbishop while FCC vice president Alma Kern and St. Edward pastor Fr. Felino Paulino are to the right. (Courtesy Filipino Community of Seattle.)

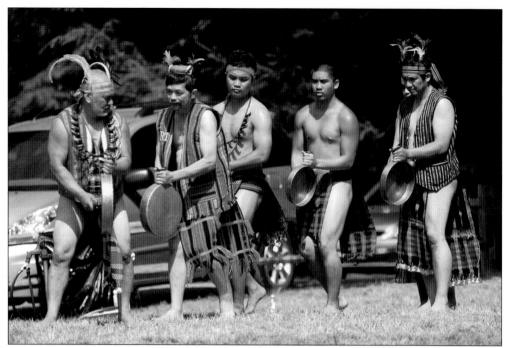

Every summer, members of BIBAK—the Philippine mountain tribes Bontoc, Ifugao, Benguet, Apayao, and Kalinga—gather in the Cascade Mountain foothills for a *kanao*—a weekend celebration of their culture and traditions. The male dancers garbed in traditional Igorot dress dance and play rhythmic beats on drums and gongs. The dress of these men is similar to what Igorot males wore while dancing at the Alaska-Pacific-Yukon Exposition in 1909. This image was taken in 2008. (Courtesy BIBAK.)

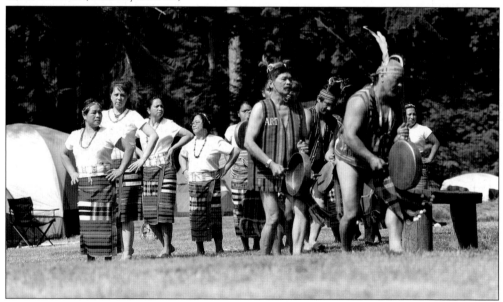

At the summer *kanao*, Igorot women perform traditional dances. Although parts of their clothing have been modified over the years, the traditional colors and woven designs of each mountain tribe basically remain the same. This image was taken in 2008. (Courtesy BIBAK.)

In our children lives the legacy of days gone by . . .

In their laughter echoes hope for brighter days ahead . . .

Inside every photograph is a story waiting to be told . . .

Inside the depths of our past awaits the key to our future.

Inside every photograph is a story waiting to be told. This historical collage tells but a few Filipino American stories in the Puget Sound region. (Poster by Timoteo Cordova.)

ACROSS AMERICA, PEOPLE ARE DISCOVERING SOMETHING WONDERFUL. *THEIR HERITAGE.*

Arcadia Publishing is the leading local history publisher in the United States. With more than 5,000 titles in print and hundreds of new titles released every year, Arcadia has extensive specialized experience chronicling the history of communities and celebrating America's hidden stories, bringing to life the people, places, and events from the past. To discover the history of other communities across the nation, please visit:

www.arcadiapublishing.com

Customized search tools allow you to find regional history books about the town where you grew up, the cities where your friends and family live, the town where your parents met, or even that retirement spot you've been dreaming about.